Bethania

Bethania

THE VILLAGE BY THE BLACK WALNUT BOTTOM

BEVERLY HAMEL

THE
History
PRESS

Published by The History Press
Charleston, SC 29403
www.historypress.net

Copyright © 2009 by Beverly Hamel
All rights reserved

First published 2009

Manufactured in the United States

ISBN 978.1.59629.637.4

Library of Congress Cataloging-in-Publication Data

Hamel, Beverly.
Bethania : the village by the Black Walnut Bottom / Beverly Hamel.
p. cm.
Includes bibliographical references and index.
ISBN 978-1-59629-637-4 (alk. paper)
1. Bethania (N.C.)--History. 2. Moravians--North Carolina--Bethania--History. 3. African Americans--North Carolina--Bethania--History. 4. Whites--North Carolina--Bethania--History. 5. Bethania (N.C.)--Race relations. I. Title.
F264.B43H36 2009
975.6'67--dc22
2009021538

Contents

250 Years

1759: *At the same time the plan for the Brethren's little village in Wachovia was explained. That is: Although the Brothers and Sisters dwell for themselves and are to care for their families, they should not think on account that they live for themselves as to other people in the world. No! Rather, they should always know that they belong to a Pilgrim-folk, so that they never get so settled here that the Savior may not have them as soon as he has need of them.*

—Bishop Joseph Spangenberg

1809: *Br. Reichel stated that this was the congregation festival, postponed from yesterday, and also the jubilee of the congregation, as in the fall of 1809 it will be fifty years since the beginning of this village in 1759. By April of the following year ten houses had been built and occupied, and the first meeting hall had been consecrated…During the Indian War, when this neighborhood was filled with fear and dread, the Lord graciously protected them from harm and accident, so that undisturbed they could proceed with the building of their houses.*

—Consecration of the new Church in Bethania

1859: *The Country was in a distracted state. The voices of abolition cried through the land. It is not right. It is not just, and so a fire burned in the deadened night…G.F. Bahnson read an historical account of the Church of Bethania from its commencement, drawn from the Church diary. At night the congregation gathered at the back of the church and after singing a hymn, went in procession to the Graveyard, accompanied by the brass bands. The grounds were illuminated by 100 torches.*

—Bethania Report

1909: *The first settlers were an industrious people—men and women of unwearied toil, who gave themselves with zeal and devotion to the building of a home here in the wilderness of Carolina which should stand for the highest and best there was in life. That they were people of great industry is evidenced by the extent of accomplishments.*

—*Bishop J.K. Pfohl*

1959: *The years are like waves in the narrow circle of the horizon that surrounds a ship on the sea. Sometimes they caress: sometimes they beat in a wild turbulence through which it seems nothing can survive—and ever the sea opens beyond. As our horizons recede into tomorrow, will the years bring peace or war?*

—*Ernest M. Eller,* Bethania in Wachovia

2009: *Bethania is a living cultural and historic treasure—not only for North Carolina but for the American South as a whole. Bethania is unusual for its frontier heritage, its Germanic pattern and continuity of character, size and population, but also for the immense amount of documentation it has produced in its normal course of its life. Few settlements begun in the colonial period offer such opportunities.*

—*Thomas Haupert,* Moravian Archive News

Acknowledgements

From the moment I set foot in Bethania, I have been on an incredible journey. I owe a debt of gratitude to many people. My initial appreciation is to John and Jo Butner, Reverend John and Louise Bowles Kapp and Mo and Martha Hartley, all of whose work inspired me and led me on the path to study Bethania's rich history.

Along the way, I became involved with the Bethania Town Lot Council and Committee, which tried to preserve all of Bethania's 2,500¾ acres. There are many who worked to stave off annexation, and they are all very much a part of Bethania's history and memory, as are those of us who live within Bethania's new town boundaries. We cannot change the past; we can only hope to preserve those memories and their rightful place in history.

This book did not come about by accident. It was an integral catalyst for my studies at Salem College and Goddard College. To Dr. Carol Dykers, Dr. Penelope Niven and Ginger Hendricks, for their encouragement and support on this project throughout my years at Salem, I offer my deepest gratitude. I also extend my appreciation to Richard Panek and Nicola Morris, my advisors extraordinaire at Goddard who helped me to uncover my writer's voice, even though my culminating thesis was different than the one with which I began. I had lost faith in my project because I believed that I was an outsider, and I thought that I could not tell Bethania's history as accurately as one who was born in this area. My deepest thanks to Dr. John Collins and Ellie Collins who believed that I could.

My appreciation also extends to Bill and Diane Cobb, the State Archives in Raleigh, Wilson Library in Chapel Hill, Gary Albert and his team at Old Salem Museum and Gardens, the Moravian Archives in Winston Salem, Dr. Daniel Crews and particularly Richard Starbuck, who has helped me with many projects over the years. I would like to thank Molly Rawls from the Forsyth County Library; Cookie Snyder and her family, who turned

many of my original glass negatives from J.L. Kapp into photographs; and Bowman Gray, whose photography captured the poetry of Bethania's changing spaces between past and present and added to the layers of life between yesterday and today. I am grateful to Laura All, from The History Press, who saw something special in Bethania's history and whose editorial input and recommendations added depth to Bethania's story.

To my husband, Bud, daughters, Kristen and Beverly, who gave me the time, space and encouragement to support my dream—I love you all. Lastly, to my Bethania Moravian Church family, and to all the people who are, or will be, entrusted with Bethania's preservation, thank you. This book is dedicated to all who have lived in or shared the memory and history of Bethania's 2,500¾-acre town lot, past, present and future.

Introduction

The Silent Village

There lieth a village on the hill
Beneath the cedar trees
Calm, and peaceful, white and still,
The home of the summer breeze.

No noise, no sound of hurrying feet,
Ever waken the echoes there;
The ivy creeps or the quiet street,
Thru reaches of maiden hair.

—*Emma Lehman*

Bethania, North Carolina, is the last of its line, a pioneer town founded on June 12, 1759, out of the need to establish the roots of religious freedom. A historically significant town, Bethania is the first planned Moravian town lot in the Wachovia tract of North Carolina. Listed on the State and National Registers of Historic Places, the town became a National Landmark in 2001.

Colonial homes, some still lived in by descendants of the first white Moravian settlers, line Bethania's main street and are symbols of how so much of the town's character remains intact. Simple yet elegantly understated, the homes represent the regional architecture of the colonial era in which they were built.

The homes have names, attesting to former owners. On the corner of Loesch Lane and Main Street is a tall, stately house that bears the name Johann Christian Loesch. Loesch's son, Israel, was a U.S. representative

Bethania's God's Acre. *Photo by Bowman Gray.*

during Reconstruction and president of the Cape Fear Bank and the First National Bank in Salem, which became Wachovia Bank. Across the street on the opposite corner is the Cornwallis house, given the name of a Revolutionary War general who spent the night in the home during a raid and subsequent encampment in the town.

Beyond the distinction of its Main Street homes standing as monuments to an earlier century, Bethania was once a thriving industrial and trade town. The Great Wagon Road of the colonial era brought soldiers, settlers and slaves through the town daily. The longest and costliest plank road of the pre–Civil War South ran 129 miles from Fayetteville on the Carolina coast and ended at the corner of Main Street and Loesch Lane.

What is unique about Bethania today is its history as a community that began as an experiment in melding cultures. Its first settlers were chosen from Moravian and non-Moravian families who created the town in a hostile frontier. In 1766, Bethanians helped found the town of Salem in the newly formed colony of North Carolina, thus contributing to the birth of our nation.

Bethania is the last surviving Germanic linear village of the original Wachovia tract; however, its survival has exacted much from its founding families. Pioneers in the true sense, they survived Indian attacks, dark forces

of nature, epidemics, wild animals and soldiers who, during bloody wars on American soil, tried to destroy Bethania's spirit. The town has endured through the Indian Wars, the War of Regulation, the Revolutionary War and the Civil War, all of which were fought within and around its borders.

Bethania's most recent battle was fought in courtrooms against annexation. That fight began in 1995 and ended in 1998, leaving an open wound. The war pitted neighbor against neighbor and blacks against whites. Although the lawsuit was upheld three times, the North Carolina Supreme Court reversed the decision. Of the original 2,500¾-acre tract, less than 400 acres remain intact, and these exclude a large group of African American citizens. In 2006, Bethania's historical Freedmen's Community was annexed into Winston-Salem.

Among the embittered were those whose ancestors had been among the first families to settle Bethania; those whose ancestors bore the marks of slavery, second-class citizenry, segregation and racism; and those whose roots were implanted deep where their forbearers once toiled. This story seeks to preserve those roots, heal the scars left behind and perhaps, in retelling its history, make Bethania whole again.

CHAPTER I

The Road to Bethania

We hold arrival lovefeast here
In Carolina land,
A company of Brethren true,
A little Pilgrim band

MORAVIAN BEGINNINGS

The Moravian religion, also known as the Unitas Fratrum, is the oldest Protestant religion in the world, having surfaced almost sixty years before Martin Luther and the Lutheran movement in Bohemia. It was based on the philosophy and teachings of Jan Hus, a Czech freethinker in the late fourteenth century. Hus was considered a heretic and was burned at the stake in 1415. His followers remained loyal, but the movement went underground until the Great Awakening of the early eighteenth century, when interest in the church was renewed by Count Nicholas Zinzendorf. Zinzendorf's estate, Herrnhut, meaning "under the Lord's watch," in Moravia became the religion's community center and fostered leadership for the church's discipline throughout the world. In the 1730s, a small group of thirty-five Moravian families traveled by ship from Europe to Georgia to establish a mission in the hopes of converting the American Indians. This settlement failed, and they migrated to Pennsylvania, where they established communities in Bethlehem and Nazareth.

Zinzendorf's theology centered on a choir system, in which everyone was divided into groups according to age or life status—married couples, widows, widowers, single men, single women, older boys, older girls, young boys, young girls and infants. Single men lived in separate buildings, as did single women, and everyone worked for the common good of the church. In

the early years of Moravian towns, only those who followed the Moravian religion were allowed to live in the community, and one's fate in life was decided by the casting of the lot. Rolled parchment or stones were set in a bowl or on the ground—one for yes, one for no and a blank meaning that the timing was not right. At other times, Bible verse was used so that all decisions were made through the Lord's will.

In the 1740s, a treaty between the Indian nations and colonists allowed for open use of the "Great Warrior Road," and settling of the southern colonies began in earnest. Since prehistoric times, Native Americans had traveled this path on their way south to herd buffalo, trade, barter and make war. Centuries later, the roadway, more of a footpath, provided a western and southern route that rolled into Georgia through Virginia and the Carolinas.

In 1749, British Parliament recognized the Moravian Church as "an ancient Protestant Episcopal Church" that encouraged colonization, and the Pennsylvania settlements prospered. The sect was ready to return to missionary work in spreading the word of Christ's teachings. John Carteret, the Earl of Granville and the last remaining feudal Lord Proprietor, offered to sell land in the Carolinas to the Moravians. The Granville tract was immense; the eastern boundary was the Atlantic Ocean, and the western boundary extended beyond the Mississippi and was mostly an unknown wilderness.

The first group of Moravian men left Bethlehem on August 25, 1752. Their purpose was to find suitable tracts of land, 100,000 acres in total, on which to build the Moravian "Villages of the Lord." The men were led by Bishop Augustus Gottlieb Spangenberg and included Timothy Horsefield, Joseph Müller, Hermann Loesch, Johann Merck and Henry Antes, who had helped to build the Moravian settlement in Bethlehem. The 450-mile journey took them down the Wagon Road toward the eastern seaboard and into Edenton, North Carolina, where they arrived on September 10. Here they met Francis Corbin, Lord Granville's agent. Heavy rains and washed-out bridges delayed their movement until September 18.

During this delay, Spangenberg found that colonial North Carolina was in a "state of confusion," particularly concerning land matters, and what laws existed were "rules and laws of which the Brethren would not think." The men tried to obtain a map of North Carolina and were told that none existed that reflected the current counties or settlements. Corbin, too, was "in the dark" as to how the lines were drawn. Patents for registered lands had been lost, and often possession of land could not be disputed. Corbin suggested that the men travel west toward the Blue Ridge, where unencumbered land might still be found, and sent with them a surveyor,

The Village by the Black Walnut Bottom

William Churton, and two hunters who were to help with laying the chains or hunting game. Subsequently, Spangenberg and his party set out in the dark. Treacherous terrain and illness affected the entire group and created further delays. Horsefield and Merck had to return to Pennsylvania.

Toward the end of December, the men came to a body of land that somehow seemed to have been "reserved by the Lord for the Brethren." Spangenberg writes, "We are here in a region that has perhaps been seldom visited since the creation of the world." The land, situated ten miles from the Yadkin on the upper road to Pennsylvania, some twenty miles from the Virginia line, was perfect, nestled in a fertile valley, with fine meadowland, lowlands and gently sloping uplands among numerous crisscrossing streams and creeks. One particular tract was noted as being rich with black walnut trees, and this would be where Bethania, the first planned town, was established.

In total, nineteen deeds, containing 98,985 acres of land, were conveyed by Granville to the Moravians. Wachau, later Wachovia, was named after the ancestral estate of Nicholas Ludwig, Count of Zinzendorf. Spangenberg left for Europe to bring the surveys to the Moravian leaders. At one point, because of money issues with the church, the land purchase was almost abandoned. In fact, the Moravians asked Lord Granville to release them from their contract. He refused and offered new terms, which were accepted. By the time the Moravian pioneers returned to North Carolina, Wachovia land, which had been entirely in Anson County, was now in a new county named Rowan.

Bethabara, A House of Passage

On October 7, 1753, a second group of fifteen single men left Bethlehem. Each man was chosen for the journey for a particular skill or experience that he could provide, including woodcutting, gardening, baking, turning and coopering. There was a shoemaker, a carpenter, a tailor, a minister, a doctor and a business manager. They all held a deep passion and belief that the Lord would guide them along the way. They followed the Great Wagon Road from Pennsylvania through the Shenandoah Valley of Virginia and then traversed the Sah-ka-na-ga—the Great Blue Hills of God. On November 7, they saw Pilot Mountain and knew they were nearing their destination, though they still had rough terrain and rivers to cross. Two men had been sent ahead to clear the road and cut down steep embankments, and they had found an abandoned trapper's cabin just six miles from the edge of Wachovia land.

The Moravians were an industrious people, and within a few days they began clearing land where Bethabara, Hebrew for "House of Passage," grew. On November 27,

> *after breakfast Gottlob, Nathanael, and Jacob Loesch, with Mr. Altem, went to the Black Walnut Bottom, to look over that section. They returned in the afternoon, well pleased with their survey; had found a good place for a mill, about four miles from here, counting straight through the forest.*

A road was soon opened to the Black Walnut Bottom. Here, the men drove their cows that were not penned for the winter because there were many green reeds. These same reeds were prized, as they could be made into musical instruments, baskets or fishing poles, and they were harvested and sent in wagons to Pennsylvania. Other men returned to hunt and shoot game because of the abundance of wild turkey, deer and bear.

By the spring of 1754, more then ten acres of fields had spread across the countryside. Fences, fodder huts, corncribs, dwelling houses and a smokehouse were added. In October, they blazed more than five miles of roadway to connect the Pennsylvania Wagon Road and another roadway to the New River.

As the Moravians began building a new life in the Carolina wilderness on land still largely inhabited by Native Americans, the French and Indian War was escalating, and British involvement came rapidly. A palisade was erected around Bethabara, and interest grew among visitors who sought a new life in the South and had heard of Wachovia and the Moravians. Strangers, outsiders or refugees, as the Moravians called those who were not associated with the sect's religious ideologies, came to the fort seeking medicine, wares, food, lodging and safety. By 1759, settlers, some living one hundred or more miles away, had sought protection within Bethabara's palisades, and the brethren had allowed eight families to build homes by the gristmill.

Up until the 2000s, the consensus was that Bethania came into being due to the overcrowding at Bethabara. New scholarly research and translations of German archival documents show otherwise:

> *In the month of May was a Synod held in Pennsylvania at Lancaster. From there Br. Joseph Spangenberg, Superintendent of the Brethren in America, accompanied by others, traveled to Wachovia bringing with him the decision which had been passed that a new small village* [Bethania] *should be begun here. Indeed it was that it should be in the so-called Black Walnut Bottom.*

The Village by the Black Walnut Bottom

"Concerning Bethania," Spangenberg wrote, "Br. Petrus Boehler brought us this name from Europe for the first little village in Wachovia." Bethania was named for the garden where Jesus was crucified, Bethany, meaning "House of Dates or Figs."

A small party set out for the Black Walnut Bottom on the morning of June 12, 1759, consisting of Bishop Spangenberg, his wife and several of the brethren: David Bischof, Christian Seidel, Jacob Loesch, Kramer, Ranke, Holter, Reuter, Bonn and Hirt. The group came to a halt in a wide valley nestled between two creeks and gentle hills. As it was the Moravian custom to call upon the Lord for a decision by casting lots, Spangenberg set to the task, and the first "Village of the Lord" was born.

Building Bethania

All this then, as I hope will serve to cause Bethania to keep a careful eye on the area where its wood and pasturage is, in order to maintain everything in good condition.

—*Spangenberg*

A GERMANIC LINEAR VILLAGE

Within a few days, another work party was sent forth. Bishop Spangenberg, Moravian surveyor Christian Gottlieb Reuter and Christian Seidel drew sketches of how the town layout should look. All of the plans followed patterns that had been in place in Europe for centuries. The one chosen for Bethania was that of a typical Germanic linear village and called for twelve *baustellen*, or building lots, above a center square where the church would stand and twelve below. The lots were further sectioned every third lot by a side lane, with back lanes running behind the building lots. Each lot was 60 by 198 feet, with the exception of the four lots that surrounded the center square. The houses were designed facing a main street and were built close together in order to serve as protection against Indian raids. Each lot was assigned a number, one through twenty-four.

Reuter's plats for Bethania show well-developed patterns of land usage. Six lots were added before the close of the year, designating where the first mill, brickyard, potter's kiln and farming strips should be located. Other early maps are finely detailed, with symbols that show locations for building stone, specific timber types, plants, meadows, springs, dry dales, valleys and steep hills and even patterns of water flow. Land surrounding the core town was divided into plots based on the soil type. Outlying fields were designated for orchards, along with fine bottomland and upland fields. Orchard and

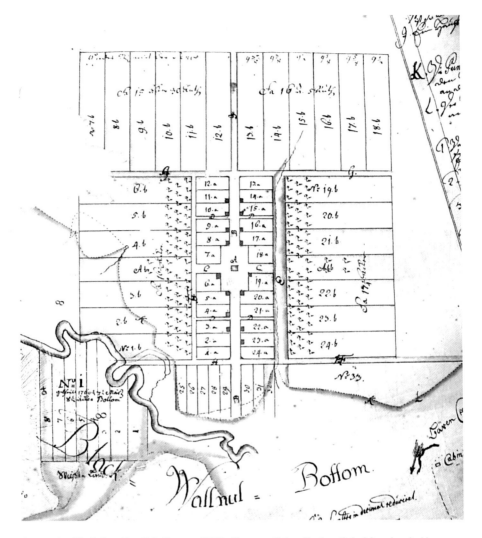

A map by Christian Gottlieb Reuter, 1759. *Courtesy of the collection of the Moravian Archives, Winston-Salem, North Carolina.*

grain lots consisted of five acres each, Black Walnut Bottom land consisted of two-acre lots and all were assigned numbers to correspond with each residential lot. Spangenberg writes:

> *We have thought that it would be good if one would set out the boundaries for the whole district which belongs to Bethania, and that the Unity should keep in its hands all the land that was not granted for this or that person*

as private property for building and meadow land. The inhabitants of Bethania are allowed the right to hunt in the forests belonging to said village, though this does not mean that the Unity has given up the rights to hunt there. They are to have wood for building, fires, and fencing in the district allotment to their village, though this is to be done in good order, the details of which will be worked out as time dictates in the future. Proprietary rights to minerals and to water for a mill were conceded to no one; rather they remain for the Unity.

Unlike the other Moravian towns in America, Bethania was unique, even though the church initially owned the land and had full say in how the land was utilized. Spangenberg was a visionary who saw beyond the patriarchal plan that would be established for the other Moravian settlements in America, including Bethabara. His idea was to institute missionary work and allow those who held similar beliefs to form a society and join those selected from within the Moravian religion in settling the new village. It was not just the houses that set Bethania apart, but also the fact that both Moravian families and outsiders, or non-Moravian families, would settle the town. The upper lots above the church were designated for the non-Moravian families, and the lower lots were reserved for those who were church communicants.

A Brotherly Settlement

At Bethabara on Sunday, July 2, 1759, during a reaper's Lovefeast, a celebration of song and a simple meal in communal spirit, a letter was communicated to the congregation from eight families at the mill asking that they be considered to become a part of the Bethania settlement. The letter was signed by Martin, Michael, Peter, George and Daniel Hauser; Heinrich and Johannes Spoenhauer; Johannes Strub; Heinrich and Johannes Schor; and Phillip Schauss. The mill families were "known" to the Moravians, meaning that the families had been living at Bethabara and were considered sympathetic to Moravian beliefs and of similar pious nature.

At a service held on July 8, 1759, Spangenberg explained to all would-be residents that this new village and the others that would be developed over the years were to be "Villages of the Lord" and established under the principle that they were communities "where nothing of worldly spirit and action should take place." Eight Moravian married couples were selected through the lot, by numbers representing the lower town lots, to move to Bethania and occupy the first homes.

At the same service, Reuter prepared a contract, a brotherly agreement, to be signed by the mill families. This agreement specified that they must remain in Bethania for three years and contribute to the church through their harvests and financial support should they reap financial benefits from the fields that they harvested. If the families chose not to remain in Bethania, the land would revert to the church.

A separate attachment listed the need to regard all rules and regulations set in place by authorities, to be mindful of proper conduct and to take care of and support their families or they could not live in Bethania. The rules outlined in this first brotherly agreement were less restrictive than those of the full communicants. Bethania was initially a "Place Congregation," where civil affairs were controlled by the church boards. The agreement was so important that it was signed by all and notarized by a justice of the peace. A general agreement was established for all of the inhabitants of Bethania that gave specific rules and regulations for land use, both within the settlement and in the outlying lots.

Amidst great doubt that such an agreement would survive, the men set out from Bethabara to Bethania to clear a new road. Through intense labor, they felled tall pines, solid maples and oak trees. Brush was cleared away and burned. Cairn sites for building stones had already been located, and stones were hauled into the town. The first log house was quickly raised.

In the meantime, a terrible sickness came to Bethabara. Mary Rogers, the wife of the English-speaking minister of the parish, was the first to die. Catherine Seidel's death on July 19 came swift and sudden, with the trumpets announcing her departure home to the Lord, as was the custom. Her husband, Christian, followed her, passing away on the twenty-sixth. Within a few days, Hans Martin Kalberlahn, Bethabara's doctor, succumbed. Other deaths occurred over the next several months, and the Bethabara brethren were prompted to lay out a stranger's cemetery because so many non-Moravians and strangers could not be buried in God's Acre. A new cemetery was built nearby and named Dobb's Parish Cemetery for the newly appointed governor of North Carolina.

The following diary entries from July 1759 paint a picture of this grim beginning:

July 9—In the morning we held a conference in regard to building Bethania. Reuter, the surveyor, was appointed to lay out the new road from the mill.

July 10—Seidel and Lash with eight men went early to make the road, and to cut down wood for the houses. Erected our tent in the midst of the forest in the centre of the location of the new town.

July 11—We had our morning devotions, in which Bishop Spangenberg gave his benediction to the whole company, but especially to the Bethania party who were beginning their work. The company began their labours by opening the road. They were served with breakfast, there being sixteen in the party. Noon arrived, and dinner was eaten in the tent in the Bethania square. After the meal we began transporting the timbers for the Grabs house. Reuter measured the square, and marked the location of the houses. In the latter part of the afternoon we had a religious service.

July 12—We were awakened by some of the brethren beginning to sing hymns, and when ready for the work of the day, we went to the place where the Grabs house is to be located. The morning prayers were conducted on this spot, and we prayed that those who would reside in the house, as well as all the future inhabitants of the town, might be blessed. The service drew us very near to each other in the bonds of brotherly love. Last evening we heard the Bethabara trumpet, three miles distant Reuter and Peterson went back to Bethabara. Kapp became ill and had to remain in his tent. At ten o'clock the old man Hauser came to cut timber for his house. Jacob Steiner presented a pound of sugar to those who were sick. In the afternoon we had a heavy rain and thunder-storm. Spangenberg came soon after, and was pleased to see that the framework was up. We had a fine evening service. Spangenberg remained all night.

July 13—After the morning service we cut out the road to the stone quarry, and made a bridge over the creek. Later a number of men came from Bethabara. Holder and Spangenberg returned to Bethabara. The foundation stones of the Grabs house are in place, and the chimney commenced. Shingles placed on the roof. Sixteen at work. By sundown we had finished our work, and returned to Bethabara.

July 15—Conference about second house in Bethania. This house is to be thirty feet long and twenty feet wide, and is to serve as a model for the future dwelling-houses. At four o'clock Spangenberg notified us that on Wednesday, Brother Grabs would move to Bethania, and he designated other brethren who would live there. Brother Grabs has already been assigned to his house. The lots were divided as follows:

No. 19.—Grabs. No. 20.—Hege.
No. 3.—Beroth. No. 21.—Biefel.
No. 4.—Kramer. No. 22.—Opitz.
No. 5.—Ranke. No. 23.—Schmidt.

July 16—We went to Bethania and the wagons followed us. Lash came later. The day's work was to clear lot No. 6, for the meeting hall [No. 18 was also assigned to the church]. This was to be the second building, and

in addition to this we were to cut more logs. The chimney of the Grabs house finished.

July 17—Our morning prayers were held on the location of the second house. The text of the day was about the servants of the Lord, a fitting scripture for the day that we laid the foundation of the church. Grabs came from Bethabara, and Lash and Seidel returned.

July 18—Peterson went to Bethabara. Grabs, his wife, and his little son William moved into their new house; they are the first inhabitants of Bethania. Service conducted by Spangenberg on the site of the new church, his text being taken from the 23d Psalm. Schoer [Shore] received lot No. 10 and Strupe No. 17.

July 19—In the afternoon Lash returned. Seidel called home by the illness of his wife. Otherwise the work continued as usual. Reuter measured sixty acres of land to be cleared. He also laid out an orchard. A road was made from Dorothea Creek. Made shingles and nailed them on. One side of the meeting hall finished. Seidel sent word that Mrs. Rogers was dead. Most of the brethren went to the funeral.

The disease that ravaged the inhabitants was sudden—the "blood boiling hot," along with a white eruption. Believed to be typhus, the disease would

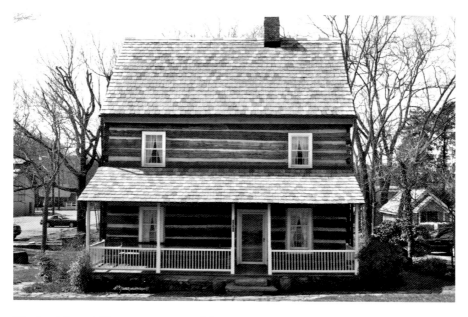

The Jacob Loesch House, a prototype of the first log homes in Bethania. *Photo by Bowman Gray.*

return as a seasonal epidemic and eventually helped spur the clearing of the adjoining swamp between Bethabara and Bethania.

Indian Wars

The path from Bethabara to Bethania was covered by thick woods and held abysses that could easily hide enemies. The Cherokees were curious of the Moravians' strange dress and language and watched the activity of the inhabitants in the new town closely. October 12, 1759, brought the announcement that the Cherokees and the Creeks had openly declared war against the English. As news of more massacres came, concern over safety grew. Between the typhus epidemic and the Indian scare, Bethania's building plans were delayed until late November, when it appeared that the sickness had run its course.

By the beginning of 1760, there were two completed houses and six more under construction. As February ushered in a hint of spring, threats by the Indians escalated, and in early March, William Fish and his son were killed a few miles from the town. Less than eight miles away, homes were burned and people were killed on the Town Fork. One large Cherokee camp was located six miles north of Bethania, and a smaller camp was just three miles to the west. Later, the Indians told of how often they tried to take prisoners but failed because they heard the watchman's horn or the ringing of the bell for morning and evening services.

Soldiers were within reach at the fort in Bethabara, and residents were appointed to maintain a watchful guard. Another new roadway was carved to facilitate wagon travel between Bethania and Bethabara.

The first *gemeinhaus*, or congregation house, in Bethania was a log structure that sat opposite from where the present church stands. The building suffered severely by the patterns of rain and eventually needed to be moved. Bishop Bahnson's commentary during the Centenary Jubilee notes:

> *It was a small building standing on the spot now occupied by Brother Oehman's shop. Bishop Spangenberg consecrated the building in early 1760 and the first reception of new members were received into the congregation, Martin Hauser, a married man, and two married couples, George and Margareth Hauser, and Henrich and Barbara Schor and from March 15 on the communions were celebrated as well.*

Ten houses were completed, and on April 10, 1760, the men brought their wives and children to Bethania. The first families in Bethania were the

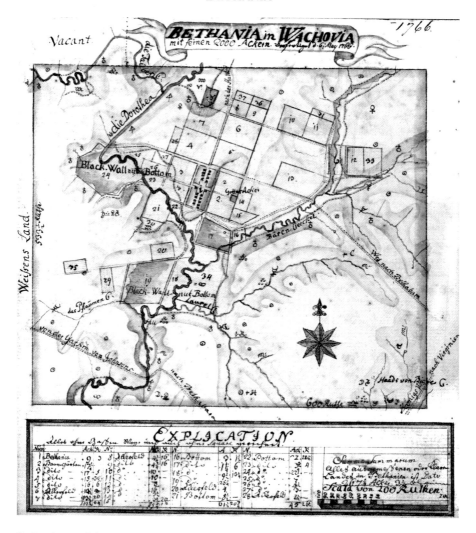

Bethania on a Wachovia map by Christian Gottlieb Reuter, 1766. *Courtesy of the collection of the Moravian Archives, Winston-Salem, North Carolina.*

Grabs; Balthasar and Juliana Hege; Carl and A. Maria Opitz; Christoph and Helena Schmidt; Johann and Catherine Elisabeth Beroth; Adam and Maria Barbara Kramer; Martin and Elisabeth Ranke; Heinrich Biefel; Martin Hauser; Michael Hauser; George and Margaretha Hauser; Henry and Elisabeth Spoenhauer; Johann and Barbara Strub; Philip and Elisabeth Schaus; and Frederick Schor, a widower, and his son, Henry Schor. Sadly, April 23 brought the consecration of Bethania's God's Acre, and the first

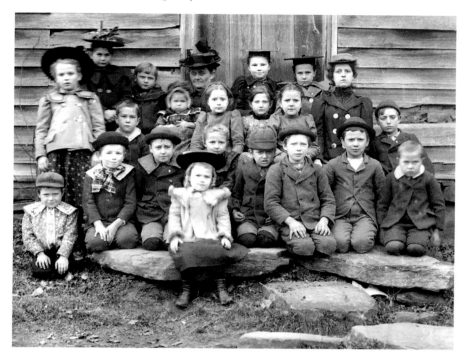

Bethania children. *Photo by J.L. Kapp, circa 1900.*

grave, with the death of the infant Mary Hauser, daughter of George Hauser. Four days later, Bishop Joseph Spangenberg returned to Europe, and Brother Nathanael Seidal took his place. By the end of 1760, Bethania had twenty-four children. On Christmas Eve of that year, the diarist records that a Lovefeast was held, in which the children "received a pretty Christmas verse and a ginger cake, the first that they had ever seen."

No Brethren's Settlement

In the beginning, despite different religious backgrounds, the brotherly agreement looked good on paper and united the first settlers in a shared purpose. However, the agreement was often the source of disagreement throughout the first century of settlement, and Bethanians were continuously recognized as troublemakers by the provincial council established in Salem. News traveled quite slowly across the ocean, but when Count Zinzendorf received this information, he wrote on May 3, 1760:

Bethania is…no Brethren's settlement; it is against our plan to mix ourselves with people who we do not know. It must be absolutely and to eternity not happen that brethren and stranger people build a settlement where they are going to live together.

Zinzendorf "had a conniption fit" and died on May 9, 1760.

The mill refugees chosen to share in the building of Bethania had a growing interest in the Moravian religion while living within the confines of Bethabara. They spoke the same German language, came from the same areas in Europe (and later Pennsylvania) and found a common denominator in worshipping Christ the Lord, but their views on raising children clashed with church ideologies.

From their earliest arrival at the Bethabara Mill, the refugee children (and parents) were exposed to new teachings, such as the choir system. Schooling and learning the roles one would take in life began in infancy. Infants and small children were placed in the sisters' care so that the "busy work" of their collective parents could be completed. Even though the first schoolmaster was a Moravian, the refugee parents felt confident in their children's education. The first school was established in Bethania in early 1761, and Brother Bachhoff moved there as schoolmaster. The children would be taught in both English and German.

Several scholarly works on early Wachovia allude to, even avow, the idea that Moravians were uneducated, but records indicate otherwise. As long as there were children, there were schools, not just in Bethania, but also throughout Wachovia. In fact, educating children was a primary foundation of the Moravian religion.

Bethania's first government was established in 1762, a committee of arbitrators, or community court, that controlled village affairs "and from time to time [made] such rules and regulations as may [have been] needed." Bethania also had a constable, a justice of the peace and men who bore arms.

During the time Bethanians were concentrating on building their homes and cultivating the land, plans for Salem were well under way. Between 1763 and 1765, numerous sites were surveyed for the new town, but the casting of the lot was the deciding factor, and approval did not come until late in 1765. Once building Salem began in earnest, "men were pulled both partly from Bethabara and Bethania" to work in the town. It would always be like this—men and women heeding the church's call and leaving one town to go to the next.

The Village by the Black Walnut Bottom

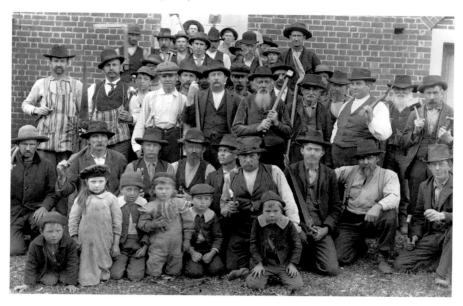

A Bethania work party. *Photo by J.L. Kapp, circa 1900.*

While this was a time of growth for Wachovia, it was also a time of political upheaval. Americans were taking sides, choosing between loyalty to the Crown and patriotism to the colonies, and they often had to sort through the confusion of whose side one was on. The Moravians were confirmed pacifists, so taking any party's side was simply out of the question. For the time being, Moravians were exempt from taking an oath of allegiance. They abided firmly by the laws of the land, paid their quitrents and taxes and refused to claim loyalty to anyone, except to God. Thus, the Moravians moved forward in building the "Villages of the Lord."

The American Wars for Independence

During these hard times our dear Father in Heaven has protected us in all dangerous circumstances, and has brought us through even when that seemed impossible…an end was also made of the illegal Entering of Wachovia land and tracts adjoining it. That many men were our enemies became apparent through these Land Entries.

WAR OF REGULATION

The French and Indian War had severely depleted Great Britain's coffers, and the Crown initiated new taxation policies that were not well accepted throughout the colonies. The Proclamation Act signed by King George III in 1763 prohibited further settlement west of the Appalachians and pushed more settlers inland. The passage of the Stamp Act, which called for a tax on all documents, followed on the heels of the Sugar and Currency Acts and launched a volatile period between 1764 and 1789. Food shortages and the dwindling of paper money provoked what was an otherwise peaceful existence in Wachovia.

The colonists became divided and separated into two factions: the Loyalists, or Tories, who were pro-British; and the Whigs, or American Patriots. The settlers in North Carolina's backcountry and western counties, organized under Harmon Husband, began openly protesting British rule, taxation without representation and the building of a new mansion for Governor Tryon. After the Proclamation Lines were set to separate the Native Americans from the colonists, many settlers lost their land, and others could not pay their taxes.

The Regulator Rebellion was sparked by the dirty ways in which the county sheriffs collected the tax. The rise in debt was epidemic, and thievery became common. An advertisement posted at Bethabara and

Bethania summoned six hundred debtors who owed more than £1,800 to the stores and taverns. Some who owed more then £20 had run away; others refused to pay and were brought in by the sheriff. Because many of the regulators were friends and neighbors, ill feelings toward the Moravians began to simmer. The regulators accused the Moravians of being on the side of the British, and the British accused the Moravians of being on the side of the regulators.

Word came that Governor Tryon wanted to have one of the Moravian brethren visit him. This was not just an invitation but a command. Brother Ettwein made the journey, taking with him a prepared address concerning the position of the brethren in Wachovia. The letter assured the governor that the brethren were loyal subjects and "desirous to lead a quiet and peaceable life." Tryon appointed Henry Spoenhauer of Bethania as justice of the peace, as he was a Freeholder and knew both the English language and law very well.

The following year, Governor Tryon, his wife and a large contingent of officials visited the Wachovia settlement. They were particularly impressed with their tour through Bethania, especially the children, who stood in front of the houses along the street. The governor remarked that "something would grow from this." Upon leaving, Tryon requested a catalogue of all the male inhabitants of Wachovia and their respective trades. The men listed for Bethania in 1767 were:

Gottl. Bachhoff, Schoolmaster & Reader
Gottfried Grabs, Shoemaker & farmer
Adam Kramer, Tailor & farmer
Michael Ranke, Farmer
Balthasar Hege, Farmer
John Beroth, Farmer
Phil. Transou, Wheelwright
Christoph Schmid, Smithy
John Chr. Kirshner, Shoemaker & farmer
Henry Spoenhauer, Cooper & farmer
George Hauser, Blacksmith, Lieutenant guard, tavern operator
Henry Shore, Farmer
Philip Shaus, Farmer & shoemaker
Peter Hauser, Weaver & farmer
Mich. Hauser, Weaver & farmer
John Strub, Baker & farmer

LOYAL SUBJECTS OF THE KING

Meanwhile, farming, house building and industry continued in Bethania. In 1768, the first two-story homes were built. Bethania needed a new and larger *gemeinhaus*, as the present one was deteriorating and floating away from the heavy rains. This time, the building was erected on higher ground. When the foundation was laid in March 1769, papers describing Bethania's growth in troubled times were placed inside a lead box and laid in the cornerstone. The *gemeinhaus* took two years to complete due to the growing hostilities between the regulators and the governor's militia.

Even though many regulators were neighbors, they were viewed with disdain by the Moravians who wished to remain in the governor's good graces. When wagons were sent from Bethania loaded with zwieback for the governor's troops in Hillsborough, open outbreaks of hostility were directed at the Moravians. Rumors had previously circulated that the Moravians had supplied arms to the Indians, and now the regulators who lived close to Bethania believed that the Moravians were turncoats. The British thought that the Moravians were pro-regulators, and their response was to hold unprecedented musters in the settlements, overseen by Gideon Wright of the colonial militia. Wright was also a justice and held land just a few short miles from Bethania.

Sometimes the scenes that unfolded were comical—the regulators entered from one end as the militia left from the other end. On one occasion, as many as fourteen hundred militiamen, fewer than expected due to a sickness that prevailed in the province, camped between Bethania and Bethabara. The taverns were kept busy with visits by both the regulators and the militia—often at the same time. Heinrich Herrman, commanding a group of regulators, arrived just as a company of militia finished an exercise in the field by Bethania. A diarist records:

> *Little good was expected from them, for the Captain* [of the Militia] *said he was becoming more and more a Regulator; he did his best to excite them, and amused himself by marching and exercising in the town and they finally fired their guns and shouted Hurrah.*

Bethania's wagons made numerous trips, delivering and purchasing goods, particularly to Charlestown, Cross Creek, Tryon Town and the governor's mansion, and they often fell under suspicion. In late November, three wagons were detained near the Yadkin River due to high waters. A group of regulators returning from a skirmish with militia in Salisbury camped

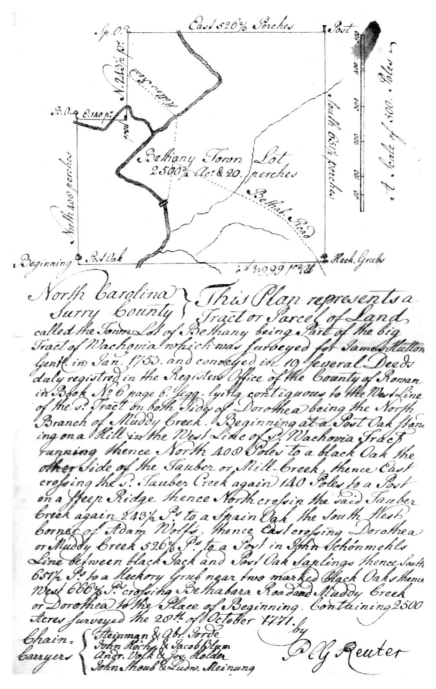

The Bethania Town Lot, 2,500¾ acres. Map by Christian Gottlieb Reuter, 1771.
Courtesy of the collection of the Moravian Archives, Winston-Salem, North Carolina.

next to the fire where Bethania's men had set up camp. The regulators warned Bethania's men that they "intended to go again in large numbers and avenge themselves."

BETHANIA IN SURRY COUNTY

In 1771, Rowan County was split into Surry County, and portions of the Wachovia tract were divided in half. This was contested because land business, courts and proceedings now needed to be transacted in a new, yet-to-be-named county seat for one portion of Wachovia, while another portion remained in Rowan County with courts held in Salisbury. The brethren petitioned the governor to maintain all of Dobbs Parish within the new county and even recommended where the new courthouse should be placed:

> *They think that at or near the Place where the Road coming from Virginia thro' the Townfork Settlement and the new Town of Salem to the Shallowford of Atkin [Yadkin] intersects an other much frequented Road coming from the Hollow and the Towns of Bethany [Bethania] and Bethabara to Widow Simmons & the New Garden as well as other Settlements would be a convenient Situation for a Courthouse, it being about 40 miles North of Salisbury & in the center of some of the greatest Settlements in these Parts.*

Surry's new seat was at first designated on Gideon Wright's property just beyond Bethania, up the old Bethania Road toward the Hollow Road. A new road was carved, believed today to be an extension of Loesch Lane, to Wright's. Wright had approached the Wachovia brethren in March and requested to borrow twenty pounds so that he could secure a deed and charter to build a courthouse. Another man, Martin Armstrong, wanted to procure a charter to have the courthouse built elsewhere in order to establish a new town called Richmond on nearby land he owned.

The regulators openly declared war in March 1771. More than seven hundred gathered along the Shallow Ford by the Yadkin River to prevent "all who were going to court." A notice was brought to the brethren that the regulators were coming to take over Bethabara's land. The Granville land office had closed in 1765, when the same Corbin who met Bishop Spangenberg's first surveying party was arrested for treason and misappropriation of funds. A claim was made that the deeds had been prepared wrong and did not have

the correct listing for Lord Granville. The regulators came as expected and tried to bully the brethren, accusing Spangenberg of illegally "taking the land on which Bethabara stands." The Moravians' response was "in short the trumped-up complaint of these people was only groundless babbling, but they were answered politely and seriously."

FRIEND OR FOE

Bethania and Bethabara were again in the middle of drama. Regulators came in on the heels of the militia and vice versa. Even so, both factions continued to accuse the Moravian brethren of conspiracy.

The news came on May 17 that indeed a skirmish had occurred between the regulators and Waddell's governor's forces in Salisbury, and "many had been killed on both sides…the Governor had granted an Armistice for the burial of the dead; and the Governor himself was wounded." As regulators passed through Bethania and Bethabara, reports trickled in of the battles at Alamance and Salisbury. Both the regulators and militia sought assistance from Bonn, who was a doctor in Bethabara. One man came on behalf of James Hunter, the commanding chief of the regulators, requesting Bonn's services to attend to fallen regulators at Hunter's home. Bonn politely declined.

This man was later recognized as Harmon Husband, who had also gone to Bethania. Husband had a price on his head, and two of the regulators had already been hanged. Tryon issued an edict that called for all regulators wanting to be pardoned to come to him. They had to swear to three things: "1st be Loyal Subjects; 2nd pay back all taxes; 3rd to give up arms." The regulators had until June 7 to submit to these rules, with the exception of the outlaws who had prices on their heads because they were to be hanged.

The brethren maintained their loyalty to the Crown because they were under suspicion and needed the Crown's protection. Their land had been split apart, and further, Dobbs Parish was in danger of being disbanded because the new act called for only Luke's Parish. All of the Moravian land formerly fell under Dobbs Parish. In their own gentle way, and to the point of incurring the wrath of their neighbors, the quiet people stood up for their church, reaffirming the foundation of Moravian beliefs.

The Moravian diarist notes, "Our position brought us into danger that our houses and towns would be destroyed; even our lives were threatened." Two of the brethren were told in confidentiality that Bethabara should have been burned. On June 4, Governor Tryon and one hundred gentlemen officials of

the Crown, along with an army of three thousand men, arrived at Bethabara and encamped in the adjacent fields on the Bethania road. During this time, amid rumors of ongoing skirmishes in outlying areas and under the watchful eye of militia guards, regulators from all over came to seek pardon. The men from South Fork brought eight hundred pounds of flour, and Bethania supplied bread and hams. The ensuing days brought pardon to many, while others were held as prisoners. The brethren were asked quite frequently to intervene. They did so in numerous cases, and in others, they turned a deaf ear. Twelve of the regulators were tried for treason and six were hanged.

By the end of 1771, Wachovia was back to rebuilding. Two new settlements, Friedland and Friedberg, were established, and Salem was well under way as the central town. The new Bethania *gemeinhaus* and *saal* were consecrated, and at the close of the year, according to the diarist, "the Bethania congregation… bought the land hitherto held on lease, and [took] over the management of it; [it] also enlarged its boundaries to the north by buying an additional piece of land." Bethania was now a 2,500¾-acre town.

THE DESCENT OF BRITISH RULE

The War of Regulation was over but was not quickly forgotten, and for most this was the beginning of the fight for democracy. The death toll during the Regulator Rebellion was not heavy, yet the fact remained that everything that transpired during the events of the preceding years was the reason that some historians consider the Battle of Alamance to be the powder keg that ignited the American Revolutionary War and caused the descent of British rule. Although the regulators who pursued pardon "dared not trust each other," there were many who felt defeated, even embarrassed. Those who did not give in to defeat joined a new rebellion.

The Regulator War, along with the series of conflicts in the northern colonies, signified that a revolt against colonial rule was well underway. The atmosphere in North Carolina was turbulent. Ill feelings in some of the neighboring areas remained as order was slowly restored in Wachovia.

In August 1772, the new governor, Josiah Martin, toured the towns and was pleased by the continued Moravian loyalty to the Crown. Although all church administration was controlled from Salem, certain rules provided for the organization of vestry men and the foundation of the parish. These men served as sheriffs, justices of the peace and as the government for Bethania and enforced rules of order for the town. New road districts were created and based on Wachovia's freeholders. The records noted that Salem had

sixty-six taxables, which included the Friedberg and Friedland communities. Bethania had thirty-five taxables and was responsible for twenty-seven and a half miles of road. The freeholders of Bethania were summoned to take over the watches along these roads:

> *From H. Benner to the Bethabara Mill Road—7 miles*
> *The old Shallow Ford to J. Holder's bridge—4½ miles*
> *Hollow Road to the Bethania Mill—4½ miles*
> *The Mill to Salisbury Road—1 mile*
> *Douits road as far as the new Shallow Ford Rd—1½ miles*
> *From the Little Yadkin—2 miles*
> *From Zeit's place on the old Shallow Ford—6 miles*

In September 1773, an organ built by Jacob Loesch and Brother Bullitschek was placed in the *saal*. The organ graced the church until it was destroyed in a fire in 1942. From the very beginning, music was an integral part of daily life to the Moravians, and Bethania had many musicians. Festal days and other church celebrations were ones of great joy and beauty and were often attended by many outside the German-speaking community.

As the regulators disbanded, the Sons of Liberty began a new uprising. Word came from the northern Moravian settlements, which were in the midst of severe trials, and Bethania's wagons traveled to Pennsylvania, bringing food and other supplies. One wagonload, driven by George Hauser Sr., took more than one thousand pounds of supplies north soon after Governor Martin refused to summon an assembly to elect delegates to the First Continental Congress that was to meet in Philadelphia in the fall of 1774. North Carolina Whigs convened under an illegal assembly without the governor, and boycotts were called for on English trade.

By the second Continental Congress in Philadelphia in May 1775, a chain reaction of uprisings had spread throughout the colonies. This was followed by a series of Coercive Acts by the British parliament that essentially declared war and provided, once again, for the formation of local militia units.

The King's Militia began to enforce muster rolls and the oath, or test, of allegiance. Until told to do otherwise, Wachovia inhabitants maintained their stance of neutrality because "God so ordered it that no one was drawn into the movement; we refused on the ground that it was something we could not meddle." The Moravians upheld the king's standard but were often pressured by neighbors for support. Wachovia settlements were back in the firing line.

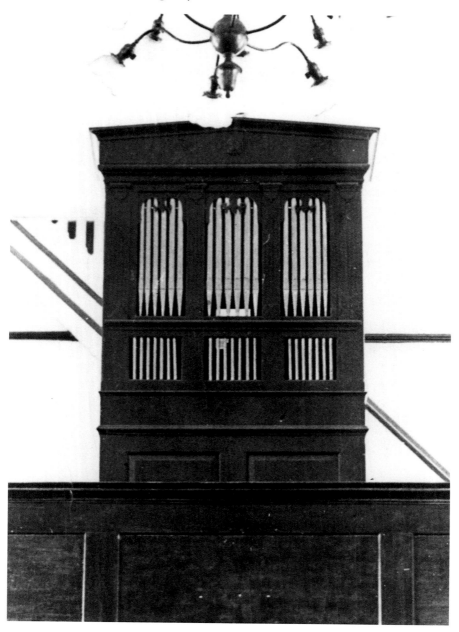

Bethania's church organ, built in 1773 by Jacob Loesch and Brother Bullitschek. It was destroyed by a fire that gutted the church in 1942. *Courtesy of the Old Salem Museum and Gardens.*

LIBERTY FEVER

North Carolina played a key role in American independence. The controversial Mecklenburg Declaration of Independence on May 20, 1775, followed by the Mecklenburg Resolves on May 31, denounced British rule and declared independence. The resolves were publicized and accredited; however, the Mecklenburg Declaration was not. The Moravian diarist recorded on July 7, 1775:

> *This afternoon a man from Mecklenburg, who had been sent from there Express to the Congress in Philadelphia, and was not returning, brought a circular, addressed to Mr. Traugott Bagge; it was signed by Hooper, Hewh, and Casewill, and contained an Encouragement to take up arms, etc. He also brought a Call for a Day of Fasting, Humiliation and Prayer, to be held on July 20th. We will think over these things, and consider what we must do about them.*

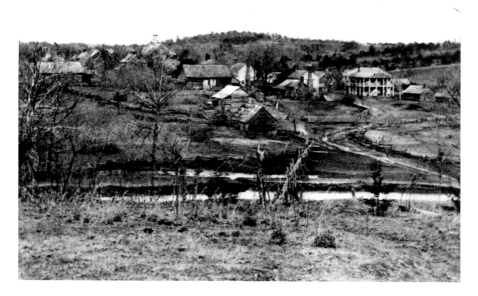

An 1880 view of Bethania and a foot bridge from Muddy Creek. *Courtesy of the Forsyth County Public Library Photograph Collection.*

On April 26, 1776, a report was received that "the Congress held in Halifax has declared *Independence* from England." The Mecklenburg Declaration helped to pave the way for the American Declaration of Independence. In 1904, O.J. Lehman of Bethania found in the archives located here a document written by Traugott Bagge, who had become an important emissary for Wachovia during the Revolutionary War. Dr. Archibald Henderson announced in a newspaper article in the August 31, 1935 *Twin City Sentinel*:

> *That again the Moravians in Wachovia furnish strong support. Traugott Bagge records in the Salem Diary the county of Mecklenburg declared itself 'frey und independent von England, and made such arrangements for the administration of the laws among themselves as later the Continental Congress made for all.*

HAUSERTOWN

The Hauser (pronounced "who's ear") family came to North Carolina in the early 1750s and owned land near the Yadkin before they came to Bethabara for protection. That the family was of good character is evidenced by the fact that they were allowed to settle Bethania. The family lineage was prone to twins, both identical and fraternal. No one knows exactly when—though the why can be assumed—Bethania was called by another name: Hausertown, Hoosiertown or other like-sounding names, though spelled differently. The first reference came in a call for "all Moravians Living in Salem Bet[habara] and Huzertown to meet at Jno Shops the tenth day of Sept Next insuing with Gunes and acer there to be trained according to Law." Visiting colonial officials were especially impressed with "old Mother Hauser and her sons and their families, forty persons, all belonging to the congregation."

George Hauser Sr. operated the first tavern in Bethania, and other Hauser men were wagon makers, smithies, gun makers and wheelwrights. Their wagons were kept in constant demand. George Sr., George Jr., Michael and Peter traveled back and forth to various parts of the country to obtain or sell supplies, wares and produce. Trips to Pennsylvania brought wares from Philadelphia and surrounding communities, as well as mail, newspapers and settlers. Trips were often made into Virginia, down to Charlestown, up to Congaree, over to Hillsborough and to the eastern coast of Cross Creek (now Fayetteville), Newbern and the mines near the New River. Deerskin was an important commodity, as were salt, flour and distilled products.

Young George Hauser may have been compelled to show his loyalty because he and his seven wagons had a run-in with Loyalists on the way to buy salt at Cross Creek. The Tories happened to be in the area at the same time. Hauser's wagons were believed to be transporting arms and other supplies, and they were stopped and searched. Troops swarmed down on not only Bethania but also Bethabara and Salem, where many were questioned and, later, exonerated.

Fortunately, Michael Hauser was a justice of the peace, and his services were needed in the new county seat of Richmond. George Hauser Sr. was an elected committeeman. Even up until the turn of the twentieth century, the upper town of Bethania was referred to as Hausertown. Pastor Eugene Greider wrote in 1875, "Some Hausertown wiseacre impressed the organist with the idea that the organ was too much out of tune to be used, hence we will have no organ accompaniment at our Easter meetings." The Hauser boys and girls often went against the rules of order. The family's unique involvement in building the southern colonial frontier merged with that of other Bethania families and contributed to the settlement's growth as a trade town. There is a saying that if you are a Hauser, under any spelling, there is a good chance that you descend from this Bethania family lineage.

END OF BRITISH RULE

By December 1776, the North Carolina Congress had adopted the state's constitution, and the parish system officially ended. The old English laws and rules were dead, and so was the currency, although many refused to turn it in for the new money in the hopes that Britain would regain control. The new paper money caused great confusion. Commerce and trade almost came to a standstill, and salt, needed for life's blood, was so scarce that prices skyrocketed. Bethania wagons often made futile trips to locate salt. When salt could be found, settlers came from as far away as two hundred miles to buy it. Disease broke out everywhere, and numerous deaths were recorded. There were at times other shortages—it was either feast or famine. Wachovia's products were in great demand, and the stores sometimes ran out within a day. Those who could pay did, but the militia required great quantities of goods and only promised to pay. The Moravians kept detailed lists of every item supplied.

There were other challenges imposed on the Moravians, such as the question of their land. The deeds held British signatures; therefore, to whom should they pay the quitrents? When the request came to Wachovia that they

needed to supply a list of their houses and lots, Bethania inhabitants thought that this meant a double tax and did not support the listing of property. Subsequently, they were summoned to court. There was also the question of the new oath, or test, of allegiance. Moravians wondered if the new government would accept their declaration and maintain their right not to bear arms.

They were more concerned about the future of church affairs, not just in North Carolina, but also in the northern settlements where new battlefields were located. In November 1777, word came that more than twelve hundred Tory wagons were counted in and around Bethlehem, and the town looked as if it were in ruins. This was not the end of Wachovia's concerns. Those who were under suspicion of siding with the Tories were ordered to take the oath and serve in the new militia or leave the country. Worse yet, their land and property could be confiscated.

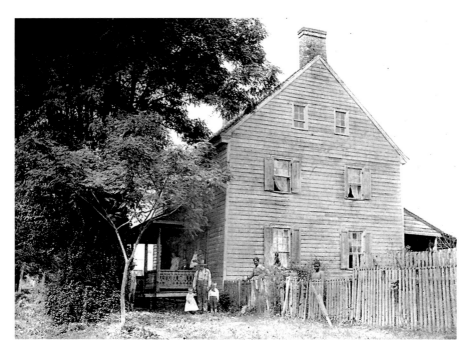

Main Street before the roads were paved. Eugene Greider, Bethania's minister in the 1870s, writes of the streets after a heavy rain "in this ugly old town which is mud up to the throat to kill civilization out of any man. Coming home in the buggy my horse required seven respites from the muddy lane to the yard, and none elsewhere on the entire road." *Private collection.*

Over the next few years, the Moravians slowly began to accept the new American government because they believed that this decision came "by the grace of the Lord." This was a difficult test for Wachovia residents and other colonists who were considered Loyalists and lived in the midst of the old regulators' battlefields. Some joined the patriotic forces and others joined the Tories, so ill will persisted against the Moravians throughout the Revolutionary War period.

County Government

In 1779, Surry Court proceedings moved from Gideon Wright's home to a new town, Richmond, which was erected on the property owned by Colonel Martin Armstrong and William Sheppard. A dispute arose, and records for where Richmond was actually situated are very hazy, partly because of the loss of colonial records, the redefining of county lines and the disappearance of the town. Today, the town no longer exists, though a map drawn by Armstrong shows a plan for tree-lined streets. An elementary school named Old Richmond in Forsyth County attests to the fact that there was a place called Richmond within a short ride from Bethania. This road is noted as the Old Richmond Road and appears on an 1822 map; however, the road is situated at the bottom of the town and does not extend from Loesch Lane as some old-timers believed. There were two roads that led to Richmond, one that extended to Wright's and another that led to Armstrong and Sheppard's. There is another tale that says, "If you want to go to Hell, go to Old Richmond." It seems that the devil himself lived in this town, or maybe it was just memories of bloodshed and other acts of horror that occurred there, such as murders and hangings.

An August 1830 deed references the "Lots in Richmond" being deeded by Enoch Franklin to Jacob Conrad of Bethania. Dr. George Wilson, after riding one day with Jacob Conrad across his vast holdings, wrote:

> *I have seen nothing today except the craving disposition of the wealthiest man we have in our section...and the real owner of this much property as this Mr. Jacob Conrad...indeed his thirst is so craving for property that he does not enjoy. Even on this day against Religion and the laws of our country he will trade with slaves.*

Jacob Conrad was a slave trader and a wealthy landowner. His acreage spread into Bethania's town lot. Conrad was also a banker, or moneylender,

and was thought to have been fair in his practice. Shortly after the purchase, Richmond Town was swept away by a tornado so intense that doorjambs and shingles were scattered as far away as Danbury and Germanton. A field of wheat was all that remained. A tale has been handed down that both of these towns were chosen as later county seats because building material from Richmond Courthouse landed there. Dr. Wilson was visiting patients on the evening of September 15, 1830:

The storm is fast gaining on me. I descended into a vale, dark, moist, and most horrid, dependent entirely on the noble animal to conduct me on the road…now the leaves begin to move in hollowed mourning and here and there a few drops are heard falling…The wind has now reached within a few rods of me. I hear the tornado. Now it had reached the dark vale in which I am…nothing can now be heard but the roar of the wind as it rushes furiously among the branches of the trees, many of which are unable to stand the violence and are hurled to the ground.

The next day, Wilson retraced his steps. The road for half a mile was literally covered with trunks, tops and limbs of trees hurled down by the wind. "I must adore that Being," he wrote, "who guarded me in that hour of peril."

Turning Point

Two battles in 1780, both in North Carolina—the Battle of Ramsour's Mill and the Battle of King's Mountain—had given Americans encouragement. Lord Cornwallis was commander of the British army in the south, and British troops and Indians, who sided with the Tories, were once again seen in Wachovia. Skirmishes flared everywhere, and the militia went into full action. The towns had to supply the militia with food and other supplies—rifles, clothing, shoes and, of course, alcohol. Records show that as much as $38,111 was owed to Wachovia for supplies. A diarist notes, "We have no complaint to make about them, if it tends to our being left in peace, though the expense of their entertainment will not be refunded to us."

Money was one issue, but North Carolina was now an American state, and this posed problems in Wachovia because there were both British and Patriot militia nearby. In Bethania, some men served as minutemen, including Fredrick Binkley; George Kreger; Joseph Hauser; Christoph Schmidt; Casper Stoltz; Peter Sehnert; Henry Shore; Johann, Peter and

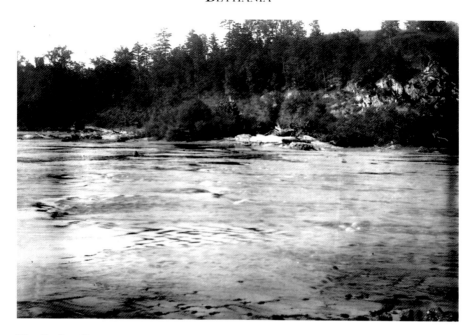

The Shallow Ford crossing. *Photo by J.L. Kapp, circa 1900.*

Samuel Strupe; and Heinrich Spoenhauer. George Hauser Jr. was called to service soon after he married and was sent to guard the lead mines near the Blue Ridge. This is where the lead was turned into ammunition for the Patriot armies in Salisbury, and Spoenhauer and Hauser carried the lead to General Rutherford there. Soon after Spoenhauer and Hauser's return, English soldiers forced their way into the house that Hauser had just purchased from Spoenhauer, found casks of brandy in the cellar, proceeded to consume massive quantities and became drunk. Hauser was arrested and taken out into the street, where he was left all night in pouring rain. The pastor and other brethren interceded, and young George was finally let go.

WHOSE SIDE ARE WE ON?

The Battle of King's Mountain on October 7, 1780, was followed by a lesser-known battle, the Battle of Shallow Ford, on October 14, and the Patriots' victories over the Tories during both battles were seen as the turning point of the Revolutionary War, although little credit is given to these defeats in history books. The Tory forces moved into the familiar territory of the backcountry

and by fall were encamped, once again, near and around Bethania and Bethabara. The Patriots were also camped here. As was the case during the Regulator War, both parties came into the towns for food and supplies. At times, "they behaved in an orderly and modest fashion," and at other times, they were "stealing or demanding tithes of animals, dairy products, damaging buildings and fields." Bethabara was used as a prison camp and had the extra burden of taking care of prisoners with "little or no help from the outside." The Wachovia diarists alternate between telling the godly part of the church's weekly celebrations and the frightening drama of war.

Soldiers on foot, and some on horses, passed Bethania daily. In June, a large battalion marched through the town; "most of them had not eaten for twenty-four hours or more and the town gathered enough together so that all might be fed." Horses regularly disappeared, and so a watch was deemed necessary during the night. In the morning, the church bell was rung to let the town know that the watchmen were leaving. In October, more watchmen were stationed in the upper and lower town when news came of a Tory attack on Richmond in which the sheriff was killed. This news was designed to inform Bethania residents who they could expect to come through the town next, the Tories or Liberty Men. Bethania families fed and housed both factions in their homes, or in front of their homes, and sometimes within hours after an enemy group had left.

On October 12, Tory Colonels Gideon Wright and his brother, Hezekiah, marched into town with more than one hundred soldiers, asking if any Liberty Men were present. This is the same Wright who had borrowed money from the Moravians to establish the first Surry County Courthouse. He was a neighbor, so of course he knew that Bethania had Liberty Men. The Tories were served bread and then left, moving on to Bethabara. Bethania inhabitants were relieved because the Liberty Men had been there all week. That evening, another group of Tories came through Bethania looking for Liberty Men and returned early on the morning of the thirteenth. A few hours later, horsemen road through the town and threatened to burn the homes because they had been shot at on the path to Bethabara and thought that Bethania men were responsible.

October 14 was quiet in the towns but not along the west bank of the Yadkin River, less than one mile from the Shallow Ford crossing, near present-day Lewisville, and a few miles from Bethania, where a battle was taking place. The battle did not last long, but it was decisive, and the Tory forces dispersed. However, many were captured and brought to Bethabara and the fields by Bethania. Both Tory and Whig soldiers had a grip on the towns. A diarist noted, "Everything was in confusion, there was no help in man."

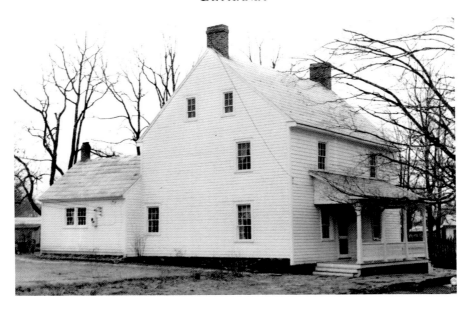

The Cornwallis House, 1942, home of Leon T. Butner. *Courtesy of the Forsyth County Public Library Photograph Collection.*

The confusion lasted throughout the remaining year because some of the captured Tories, known to the Wachovia neighborhoods, were released, providing that they serve six months in the American army. Before doing so, they were allowed to go home to their families and wash their clothes. As in the War of Regulation, accepting this dramatic change from friend to enemy and back to friend again did not come easily. Even the court at Richmond did not convene because no lawyers came forth to represent the former enemies. Michael Hauser Jr. was attacked by a Tory Irishman who threatened to kill him. This attitude was rampant, even though some wished to make amends. The war was not yet officially over, and many Tories held on to the belief that the British might win. Cornwallis was advancing with his troops from South Carolina and was well on his way through North Carolina to meet with George Washington, the commander in chief of American Patriot forces.

CORNWALLIS SLEPT HERE

In preparation for Cornwallis's advance, Bethania's wagons were kept busy procuring lead from the mines in Virginia. General Greene was camped

nearby and issued orders for ammunition and rifles to be supplied by the Moravian towns. In Salem, a barracks of sorts was built for soldiers who could not pay their way. In Bethania and Bethabara, the barracks were in the surrounding fields. It was becoming obvious that another major confrontation was in the wind. There wasn't much that the Moravians could do other than comply with the orders. The troops called for flour, meat and particularly brandy, as well as other distilled products. One Salem diarist stated, "All these demands were made with threats, which sounded as an excuse to plunder the towns."

The soldiers "tried to lead the Brethren to join them, but they did not succeed." George Hauser Jr. once again created a stir. He and other men were forced to drink to the health of King George. "While his [Hauser's] glass was poised in the air he spoke what was to be the health of the King and in reality his combined words spoken in both German and English meant, 'to Hell with the King.'" George was in deep trouble, and the officers prepared to attack. Other men jumped to George's defense, explaining that it was simply the difference in manner of speech and the German words for "hell" and "health" sounded so much alike.

There was no middle ground, except fear and courage, and sometimes these went hand in hand and made uncommon heroes of the Moravian people. When the redcoats approached Bethania on February 9, there were over seven thousand troops. A diarist noted on February 9, 1781:

> *We expected the return of our guests of yesterday, but instead about eleven o'clock, a company of English dragoons arrived, bringing an order from Lord Cornwallis, for brandy, meat, meal and bread, and instructions that our mill should grind all it could, and that in the afternoon our wagon should take it to Bethania, where there were more than seven thousand men. In the afternoon the Commissary came for 100 gallons of brandy, more than 300 lbs. of bread, and all the meal that was ready...Then came a company of German Tories, with an order for cattle for the army—just now the question is not who are friends of the land but who are friends of the king. The last named company seized several travelers here, and took them to Bethania, to the main camp.*

Despite the proximity to Bethabara, and even to Salem, no one from either town could help, and so the strain was handled by Bethania's people. The officers occupied the houses, while the soldiers camped on every available open space. Some of the sisters took the small children to safety in the schoolrooms or cellars. Other women prepared the food or were called

A scene from the drama *The Home Road*, written by Kermit Hunter for Bethania's 200th anniversary in 1959. *Courtesy of the Forsyth County Public Library Photograph Collection.*

upon to nurse the sick and wounded and do what was necessary to remain strong and then clean up afterward.

Cornwallis's troops finally left, but not without stealing, destroying and leaving behind several wagons filled with food and supplies. More than sixty head of cattle were slaughtered, along with other farm animals penned within the town. The last order demanded twenty horses, but Bethania did not relinquish the horses easily. Even an attempt to hold Brother Ernst hostage could not dissuade the men, and at two o'clock in the morning, young Jacob Hauser and Jacob Stoltz were wakened and sent to find horses in the neighboring area. But it was already too late by the time they returned. Still, they managed to find seventeen, six of which were taken from the English teamsters, a fact that went both unnoticed and unpunished.

THE CABBAGE WAR

While the two young Jacobs were unlikely and industrious heroes, there is the legend of a head of cabbage and a small iron pot that is reportedly held by the Wachovia Historical Society. (The pot, that is, as the cabbage is long gone, presumably eaten.) While the males of Wachovia achieved notoriety, the women did not just sit back and let their men handle all the confrontation of battle. They were every bit as brave as their husbands and sons. According to legend, some cabbage was in the process of being cooked when a small iron pot was taken by a soldier who failed to see the importance of what even one seemingly insignificant piece of kitchen equipment meant to a pioneer wife.

The soldier scoundrel walked off with the iron pot and marched to Salem with the rest of Cornwallis's thousands of troops. The irate Bethania wife followed (even though Salem was some nine miles away), managed to get the pot back and brought it home to Bethania, where it most likely saw at least another century of use before it was donated to the Wachovia museum.

CHAPTER 4

Wagon Road to Plank Road

We have made it our rule, in these times and under the new Constitution, to be subject to those in authority over us, and to submit to all laws that they have made, so far as they are not against our conscience, and against the plan which the Saviour has given to the Brethren.
—*Frederick Marshall*

INDEPENDENCE

The Continental army and subsequent government were now in control, and the next few years were times of conformance and acceptance. No one knows what normal is, but life seemed to be turning around when the last of the troops left Wachovia after Cornwallis's departure. Peaceful might be a better word to capture the environment, even though there was sadness. The land lay in waste in many parts of the colonies, and once again, the rebuilding of lives took place.

The brethren were encouraged to have more visibility in and exposure to this new government in the form of members in the assembly and justices of the peace. As freeholders, Bethania had had representation from the beginning; however, Bethabara no longer did, nor did Salem until Bagge was elected as an assemblyman, along with George Hauser, who served for seven terms. Michael and George Hauser also served as justices of the peace in Bethania.

In September 1782, it was proposed that Bethania residents should take a long lease on their lands, and this proposal was accepted by the majority of the house fathers. Trustee for the Unity of Brethren Frederick William Marshall's report to the Unity's Vorsteher Collegium dated October 1, 1782, states, "With the residents of Bethania it has been agreed they are to pay 6% yearly on the agreed value of £800, together with the Quit Rents,

and are to receive a lease for fifty years, renewable forever." The lines were redrawn and a site was chosen where the brethren—Michael Ranke, George Hauser Sr., Heinrich Schor and Peter Hauser—built the new mill. Because this mill was to serve for the financial prosperity of the church, the Bethania congregation owned the land.

Money was an increasing issue. Virginia paper became obsolete, and soon, so did North Carolina's paper. The Moravian villages had accumulated a substantial amount in tickets. The tickets were the same as IOUs, meaning that all the products and services that were supplied or confiscated during the war years had promises to be paid.

The problem was that there was no real money, or money equal to the value of tickets. The alternative was to exchange the tickets for "specie certificates," which could only be used for paying taxes, confiscating land from traitors or for Negroes. Bethania already had men recorded as day laborers and slaves. Several families owned land outside of Wachovia and within Bethania's boundaries where plantations were established. In 1782, the Salem Board decided that both Bethabara and Salem tickets were to be used to pay the land taxes. Bethania's men used the certificates to purchase confiscated land in the territory that became Tennessee and to purchase slaves.

Bethania's growth as a thriving town and agricultural community did not happen without the use of slave labor. This was a period when patterns of slavery emerged throughout Wachovia. The church did not approve of an individual owning a slave and instead made the purchase on behalf of the church. This was not the case for Bethania. In December 1782:

> *Br. Stotz collected the tickets from Bethabara and Bethania and went with George Hauser Jr. and Col. Martin Armstrong to make the exchange in Salisbury, to be used in buying Negroes at the vendue there on Dec. 15. Some of these Negroes can be used to advantage in our towns, the rest to be sold. The value of the certificates and the risks shall be divided proportionately between the holders of the certificates.*

BACK TO BUILDING

After the tentative peace treaty in Paris on January 20, 1783, a proclamation issued by the first United States governor to do so, Alexander Martin of North Carolina, decreed that the Fourth of July was to be a "Day of Thanksgiving for Peace," and all the congregations in Wachovia were "instructed to observe the day." Records indicate that Wachovia towns in North Carolina were the

Know all Men by these presents, that we George Hauser and Francis Rose, both of Stokes County, State of North Carolina, as Executors of the estate of John Puryear Deceased, in consideration, that a certain Negrocwoman named Celia, about 21 years old, with her female child named Phyllis, about one year old, has on the 15th day of November 1809 been purchased from George Hauser, one of the executors of the estate of John Puryear Dec. by Doctor Frederick H. Shuman for the sum of Four hundred and fifty Dollars, the receipt of which is hereby acknowledged: Have this day confirmed the bargaining, Sale and delivery of the aforementioned Negrocwoman Celia with her female child Phyllis, and all Celia's increase since to Doctor Frederick H. Shuman. And we do hereby warrant and defend the said Negrocwoman Celia, with her female child and all Celia's increase to Doctor Frederick H. Shuman, his heirs and assigns for ever against any claim of all persons whatsoever. In witness whereof we have hereunto set our hands and seals this 20th day of December 1813.

Signed, sealed and deli-
vered in the presence of:
John H. Hauser
Banner

George Hauser {Seal}
Executor
Francis Rose {Seal}

George Hauser's slave chattel of Celia and Phyllis. *Courtesy of the collection of the Moravian Archives, Winston-Salem, North Carolina.*

first to observe celebrating July 4 as the Day of Independence. Bethania celebrated with a daylong celebration that began with church services and public speaking. The diary notes that "an unexpected number of outsiders were present."

The aftermath of the war years continued to bring confusion to many parts of the country. By 1784, North Carolina money became worthless,

so much so that hard money was hidden in wax on trips to Pennsylvania or other states. Farmers were forced to abandon their land because of the high rents. Alternatively, squatters on Wachovia land forced lawsuits and legal proceedings. People still came to Wachovia to purchase goods because of the reputation for excellent wares and low prices. In the country congregations, concentration was on cultivating the land and replanting fields in order to produce cash crops. Bethania's wagons traveled back and forth to Charleston with loads of tobacco and grains and to New Bern and Cross Creek with other produce. Several more mills were completed and put into use. While there was a shortage of building material in the other Wachovia towns, Bethanians began to make improvements within the town.

The steps leading up to the *gemeinhaus* were replaced with stone, and a basement was laid. George Hauser Jr. set up the framing for his smithy shop, and others followed suit, establishing new businesses. Travelers and wagonloads of families, and even herds of cows, drove through the town. Many were seeking new land in Virginia, South Carolina or to the west. At the close of 1785, Bethania accounted for 245 inhabitants, 95 of which were communicants of the church. The following families are just some

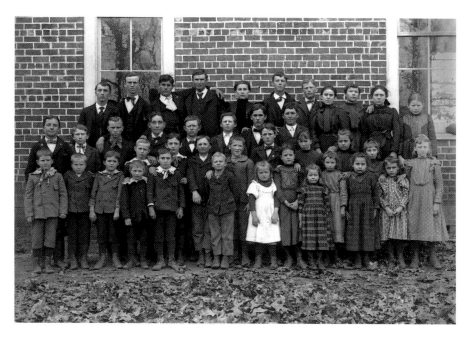

Bethania children. *Photo by J.L. Kapp, circa 1900.*

who were mentioned as living on plantations and farms on Bethania land: Volk, Stoltz, Leinbach, Krause, Conrad, Hauser, Strub, Daub, Werner, Holder, Müller, Spoenhauer, Kapp, Loesch and Binkley. New settlements appeared in the neighborhood, such as Pfafftown, [Bruxe] Brookstown and Shoretown.

MORE GENERATION WOES

The pattern for society in Bethania was clearly different than in any other congregation town in Wachovia. When Bethabara requested to have more craftspeople and trades, the church board responded by reinforcing the entire plan for Wachovia, and the growth of Bethabara into anything greater was denied. In 1786, a society in connection with the congregation of Bethania was formed. This society consisted of:

> *1. Persons living outside the town who wished to be associated with that congregation.*
> *2. Children of members living outside the town, when they reached the age of Older Boys.*
> *3. Persons living inside the town who, with the consent of the committee, have been bound to Brethren to learn their trades, and who ask for closer connection with the congregation.*

Other changes were occurring within Bethania and attracting reprimands by the Salem Board. For instance, the upper town families held different beliefs on child rearing:

> *Harvesting commencing towards the end of June, a number of young people made themselves guilty of disorderly conduct, for in spite of previous admonishments and warnings, several boys and girls insisted on cutting the grain in mixed company.*

This behavior set the trend for the future and a movement away from the "close discipline and regulations of individuals by the church." The transgressions of the young people and parents from the upper town were the object of many meetings and conferences well into the next century, particularly as the children in the upper town began to influence the children in the lower town.

The problem rested in the fact that both sexes participated in joint ventures. Orders came from Salem that this practice "must stop"; the orders were

ignored, and now the lower town's young people were following suit. The boys were regularly noted for wrongdoing. Jew's-harps, or mouth organs, were popular, and it was "recommended that the young men not stand on the street corner playing them so late at night." Curfews had to be initiated when gardens in the lower town were "wantonly injured." The house fathers held a conference, and it was decided that

> *parents must be reminded that they should not allow their sons to sleep in the sheds, which gave them a chance to do things they should not. G.C. was told that he must send away from his house his spinner, who was a notorious person.*

The young women of Bethania were equally as strong and outspoken, and yes, the females, were "bad girls" too. One older girl had a bear for a pet that she kept on a chain in the yard. Another girl went hunting during the night and became lost. She was found safe, having climbed a tree to sleep. Two of the young women went with a married sister to visit several plantations. "They did not ask permission, which was breaking the rules," the minister wrote. "My wife will speak to them about this." A daughter of J.H. went to live in the outside neighborhood because "her gross sin made it necessary to leave the village when J.H.'s single daughter gave birth to a son." A D.B. and S.E.H. were asked to leave the congregation "because of their bad conduct." They married a week later, and five months afterward, in early October, "Br. Wolle went to a neighboring farm and baptized the daughter born to them the preceding night." Sadly, the baby died and was buried two weeks later.

The older women had times of notoriety. Although the names are protected, two sisters created a disturbance on the street and came to blows after a shouting match. It seems that one of the women's horses escaped and did damage to the other's fence and yard. This was evidently serious because a lawsuit was threatened, though it did not come about, and the women apologized to each other. Hannah Hauser is another woman frequently mentioned because she lived beyond the town on her own farm. Even when she was well into her upper years, she could wield a gun as well as any man, ride a horse and run a plow.

On the other hand, the education of girls was important. From infancy, children were separated from their parents and looked after by others in the congregation. Boys and girls were taught separately. Every accommodation was made so that each child had equal opportunity to attend school. During harvesting day, programs were sometimes suspended but were then made up

with evening schools. There were also boarding schools in Salem and even in Bethania. Of note is the first female boarding school established in Salem in 1772, the oldest educational institute for females in the country and the thirteenth-oldest college for women. Kinder schools were held for the mill children at Bethabara as early as 1754.

By the end of the eighteenth century, Brother Jacob Loesch had returned to Bethania and had opened an English school where thirteen boys were enrolled. The plat map of the Bethania Town Lot in 1822, lists eight buildings as schoolhouses. These were also meetinghouses where other denominations' preaching was held. One such building became a schoolhouse for Negro children and a place for holding church services for the slaves.

As plantations and farms grew, so did the use of slave labor. Tobacco, flax and other grains were important cash crops, along with meat and dairy products. George Hauser Jr. purchased 170 head of cattle and brought them to Bethania, and "everyone looked at them, no such large and fat cattle had been seen in this neighborhood." The cattle were herded to the former plantation of Casper Fisher, who sold the plantation to Hauser. Some of the cattle were sold and others were used for the first major dairy. Hauser also purchased a "blanketed horse" for 8,300 pounds of tobacco, valued at ninety-one pounds hard money, because "it is said to have good qualities of a race horse."

BETHANIA IN STOKES COUNTY

As the economy slowly recovered, Wachovia was moved out of Surry County in 1789 and formed into the new county of Stokes. The seat was established in Germantown, where it remained until 1849, when Forsyth County was formed.

In the meantime, local government fell under church rule. There were two governing bodies in Salem: the Aeltesten Conferenz, which oversaw all aspects of the spiritual life, including the choirs; and the Aufseher Collegium, which oversaw all economic and material aspects of the communities. The governing boards operated jointly to control the affairs of the country congregations. The Salem Board and its unity principals were far more stringent and controlling than so-called local governments as we know them today. In addition to the church boards, each congregation had its own committees made up of the house fathers that further oversaw affairs within the community.

Nevertheless, Bethania did things differently, and the Salem Board did not approve of the fact that Bethania made its own decisions. "It must be and remain a definite rule in Bethania that no one shall buy a business or

sell a house, or the like, without the knowledge of the committee." When the general lease for all of Bethania land was terminated, the new leases were signed by individuals who felt that they not only had the right to determine what improvements they could make on their land but also they did not need to ask permission who should be allowed to live in Bethania. The rule was that residents could only be approved by the church boards. When a resident was kicked out of one town, he always made his way to Bethania.

There were other rules broken—rather, decisions made against church restrictions—such as forming partnerships and establishing businesses in Bethania. The Salem Board not only disapproved of this, but it also requested formal annulment concerning what had transpired with the Casper Fisher House in the upper town.

> *If the moving of Christian Loesch to Bethania means a new partnership and the opening of a third store, we would not approve that...Before Christian Loesch moves to Bethania, he should explain to the committee how he expects to support himself.*

The Hausers had already provided for young Loesch by allowing him to marry their daughter Gertraut (Gertrude) without the church's approval, and they offered the couple the vacant Fisher property by signing over the lease to Loesch. This time, the Salem Board issued an official edict: "The Bethania committee should declare null and void the private sale of the Fisher house to Johann Christian Loesch, as such a private transaction has broken the Bethania contract." Loesch and his bride moved in anyway. Shortly thereafter, when George Hauser Jr. erected a new store made of logs, "things went in a very worldly fashion, and the local people lay the blame on the outsiders who came to help."

Soon after this, another young man, Franz Stauber from Salem, married one of George Hauser Sr.'s other daughters, Elizabeth. This did not go over very well either. Moravians did not choose a marriage partner—the lot, or the will of the Lord, did. Young women can be very stubborn, and it was the young women and men of Bethania who were responsible for marriages chosen by the lot falling by the wayside. Surprisingly, girls from the lower town were equally outspoken and supported the upper town girls by choosing their spouses. Bethania's young people and their parents continued to ignore the rule that required them to seek approval for marriage to someone outside the church. They also continued to allow almost anyone to settle in Bethania. Eventually the church conceded to allowing young people to choose their own partners. Other matters were a different story.

The Village by the Black Walnut Bottom

When the proper chain of command was approached, outside ministers from different religious sects were allowed to preach. On one late day in May 1790, two Methodist ministers asked Heinrich Schor and George Hauser Jr. if they could preach in Bethania's *saal*. While the two men responded "that they had no authority to do so," they agreed to allow the ministers to preach in one of Hauser's sheds. This was not looked upon in good light by either the Bethania congregation or the Salem Board.

George Washington's visit in 1791 proved to be a momentous occasion for all of Wachovia, and the preparations before this visit extended into all the country congregation towns. For a short while, the focal point was taken away from Bethanians' actions, but then the Hausers once again gave consent for a young family member to marry outside the church. Shortly thereafter, when Samuel Sehnert of Bethania became engaged to an outsider, he was told he had to leave the congregation. This led the Salem Board to issue another edict for Bethania:

> *When a brother is to marry a person from another place, she is not to be brought with the ceremonies usual to this country, because of the disorderly conduct of the young people, she must be brought by her parents.*

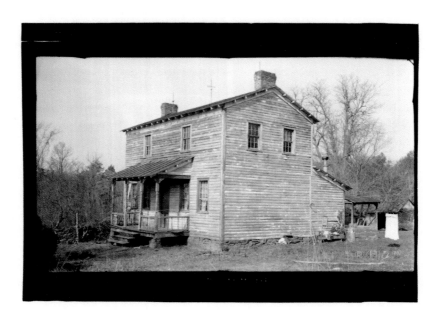

The Wolff House. *Collection of the Old Salem Museum and Gardens.*

GUILTY OF DISOBEDIENCE

There was little that the Salem Board could do, even though it demanded that those "persons who lived and dealt contrary" to the rules and regulations and the guiding principles of the Moravian religion "be sent away." Bethania rarely complied. The church boards could and did enforce the rule of property rights, which kept outsiders from leasing or owning property. In 1792, they sent notice to the Bethania committee that they were canceling the contract with the congregation, "as it already had been broken by the residents of the village in a number of ways." What ensued was a bitter internal battle between residents of the upper and lower town that lasted for the next thirty years. The problem began with the division of the house fathers, some whom had built plantations in the outlying area.

> *More than half live in the town and the rest on plantations. Those in the town are largely farmers, also, and many years ago a general contract was made, the chief condition being that only genuine Brethren and Sisters should live in the village. In spit of this again this year a family has moved in, in opposition to this condition and supported by disloyal persons, and after several reminders the congregation declared that it was not in the position to help the situation. Nothing was left to do, if Bethania was to continue to exist as it was founded thirty-three years ago, but to cancel the rental contract, and to make a new contract with such residents as showed a desire to hold the original purpose, and to guard against such disloyal persons.*

The Salem Board declared Bethania's leases null and void, and new contracts with individuals were made. Several people did not sign because they did not like the terms of the agreement. A total of twelve house fathers signed the new contracts. At this time, there were thirty-three married couples inside the town and seventeen out of town. The names of those who signed the contracts as reported are John Beroth, Adam Butner, John Nicholas Boeckel, William Grabs, Michael Hauser, Peter Hauser, Anna Maria Kürshner, Charles Gottlieb Opiz, Gottlob Ranke, Abraham Transou and Philipp Transou.

This did not make the provincial elders or the Salem Board happy, and on March 12, 1794, Frederick William Marshall, as proprietor of Wachovia who held the deeds, issued a declaration to several of the men who were partners in Bethania's mill, telling them, "Your keeping Possession yet is a Trespass on my Freehold." The Staubers were also instructed that they were

The Village by the Black Walnut Bottom

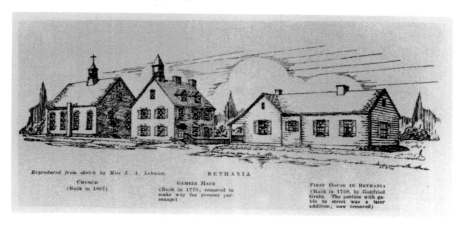

A drawing by Emma Lehman showing the church, the *gemeinhaus* and the first home built in Bethania for the Gottfried Grabs family. *Courtesy of the collection of the Moravian Archives, Winston-Salem, North Carolina.*

to leave Bethania, so they moved Bethania's northern line. On March 31, 1794, it became "necessary to notify some of the persons living here that they had no right to occupy their lot, and this has led to confusion, even to actual sin, and has greatly disturbed the residents, neighbors, and outsiders." Those who did not sign banded together, hired a lawyer and refused to give up possession of their lots. A July 21, 1794 correspondence from Marshall, read, "The Bethania suit is postponed from term to term; and meanwhile the people change their minds, and some show regret." The suit would not be completely resolved until 1822.

The new century ushered in many changes. Within the town, houses were given a fresh look; some were even torn down with new ones built in their place. Bethania began to experiment with different types of brick making. A new brick church was designed, and on March 19, 1809, it was publicly consecrated as the first fifty years of the founding of Bethania were celebrated. Although the Bethania Moravian Church was gutted by a fire in 1942, the church's presence has been as consistent as the people who contributed to the cultural identity of the community, including the slave population. A diarist noted in 1817 that at the Easter service for Negroes in the afternoon, "they filled twelve rows of benches in the church, seemed to listen attentively. And sang loudly the hymns of which they knew the tunes."

Echoes of Change

Permission shall not be given to any body to live in Bethany, or to be a possessor of a Lot there, before this, our Brotherly Agreement has been laid before him, and he with mature deliberation & clear knowledge of the whole why & whereto…by his signature has bound himself to these rules in the presence of the Committee.
—*Bethania Society Rules and Regulations*

END OF THE LEASE SYSTEM

In June 1822, the provincial elders conference voted to have Johann Christian Loesch take over the "farm, tannery, and distillery of Bethania at inventory value." He could purchase this at 25 percent discount rather than sell it at vendue (public auction), or the Salem Board could open a second store there, which it did not want to do. Loesch's takeover of these thriving businesses, as well as the tavern, in fee simple was significant as this was "the beginning of the change in holding of the Bethania lands." The end of the lease system signified the end of Salem Board's control. More or less, that is, because it still grumbled when Bethania's inhabitants went against the rules.

The Salem provincial elders noted:

> *It may be expected that the changes in Bethania will lead to the ownership of lots there by persons who are not members of the Bethania congregation, but the Committee and the housefathers will be urged to do their best to limit it to members.*

Bethania land was surveyed, carefully accounting for all existing lots and ownership of land on the 2,500¾ acres, and on December 14, 1822, the Salem provincial elders noted:

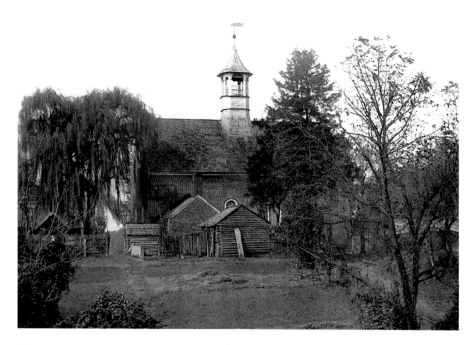

The Bethania Moravian Church, with a view of the corpse house. The corpse house is where the bodies were kept before burial. *Photo by J.L. Kapp, circa 1900.*

Today most of the housefathers in the town bought the land, which they hitherto held under lease, each taking twenty or more acres in addition. They gave bonds for the purchase price to Br. Theodore Schulz, who had come from Salem with Br. Meinung for the purpose.

By owning the land, families could cultivate the soil how they wanted to. The release of the leases to Bethanians ended the more than thirty years of bitterness that had been created during the first land battle.

The ability to forgive and forget came slowly. Sometimes people left because bitter disagreements could not be resolved. Living in such proximity to others in Bethania was not utopian. Brotherly love was difficult to maintain and was tested many times during Bethania's 250 years of existence. The brotherly agreement was revised, old rules that were no longer needed were eliminated and a shorter, cleaner version was approved. This agreement temporarily healed some wounds. By the close of 1822, other wounds began to grow deeper, such as the wounds of slavery. "In the afternoon," the minister wrote in early 1825,

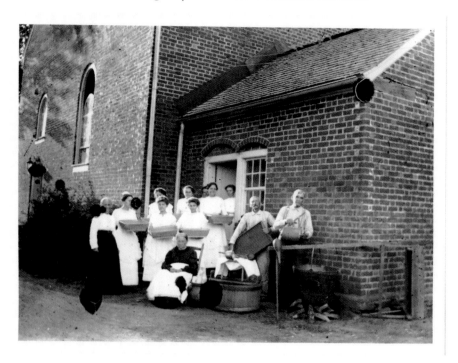

Bethania church *dieners*, "servants" in German, who served during the Lovefeasts. *Collection of the Old Salem Museum and Gardens.*

a Negro child was baptized in the church; its parents belong to Br. and Sr. Christian Loesch. Then by request I rode to the widow Schemel, two miles from here where I baptized another Negro child, whose parents belong to her...During February two children of our neighbors were baptized and seven Negro Children...In the afternoon there was a well attended meeting for Negroes.

THE ROAD TO INCORPORATION

In May 1825, a Bethania diarist recorded that residents were roused from slumber by the terrifying cry:

"Fire! Fire!" Fire had broken out in the stable on the former schoolhouse lot, now occupied by Br. Samuel Thomas Hauser. By God's grace there was practically no wind, so the adults and children, white and black, who

rushed to the spot, used the fire engine, and tore down the stable, were able to put out the fire before it spread. For this gracious protection of our town, we gathered in the evening and on our knees gave thanks, humbly and from our hearts.

The next day, "in the evening the men of the town gathered, and arranged to procure fire hooks, and to provide for testing and improving the fire engine." Although Bethania had a fire engine and an outline for handling fires when they occurred, there was not a formal declaration. This soon changed, and in 1837, those entrusted with organizing the fire company met and prepared rules and regulations, which are preserved in the Moravian Archives in Winston-Salem. Names that appear are H. Conrad, E. Shoub and Joe Transou; appointments by the engineer H. Butner, D. Butner, E. Lehman, Edward Butner, Joe Transou and William Lehman to attend to the engine; and Solomon Transou, Michael Butner, Tim Transou and Lewis Grabs. The next step was to incorporate.

The acts to incorporate the town of Bethania and the Bethania Fire Department were read three times, beginning in December 1838, and they were approved in January 1839 by the State of North Carolina. Mysteriously, the records that the town acted upon, instructing it to approve incorporation, disappeared. Yet a slip of paper posted in Bethania states:

All the inhabitants of Bethania are requested to meet at the shop of Elias Schaub on Saturday 13th at early candle light for the purpose of adopting or rejecting the act of incorporation ratified on the 3rd of January, 1839, and an act to authorize the forming of a fire engine company in the town of Bethania, Stoke County.

Attached to the official act was a copy of the 1771, 2,500¾-acre town plat map prepared by Reuter. The boundaries were distinct and were given in the same metes and bounds as were recorded on the 1771 map and the 1822 plat map. Even names for the first commissioners appeared on the document:

The Government of the Town of Bethania shall be vested in the following persons and their successors, viz. George F. Wilson, Solomon Transou, Peter Transou, Elias Schaub, I.G. Lash, said Board of Commissioners shall have the power to appoint a Town Constable and Treasurer, to lay and Collect Taxes on Town Property.

The Village by the Black Walnut Bottom

North Carolina is not called the Rip Van Winkle State without just cause. There is a tale that Bethania fell asleep and never had the meeting that should have established it as a real town. There is another tale that Bethania's pastors were becoming too domineering and dictatorial, particularly Pastor George Frederic Bahnson, who served the church until April 1838. Julious T. Belcher took his place, and things more or less quieted down, so the townspeople decided not to pursue a charter—at least, no one has found the slip of paper that might have proved otherwise. There are records, however, citing the "Town of Bethania," as well as records for the district of Bethania, bills of sale from businesses in Bethania, post office records and even records of the founding of the Bethania Stock Company. This simple oversight (not pursuing a charter) caused Bethania to lose the land suit battle in 1998.

A TIME OF PROSPERITY

Bethania prospered during the antebellum years. The longest and costliest plank road in the South, dubbed the Apian Way, ran 129 miles from Wilmington and the Cape Fear to its western terminus in Bethania. This plank road ended on the corner of today's Loesch Lane and Main Street, where the Lash family home, store and tobacco factory stood. Also known as the farmer's road, it opened the door to Bethania's antebellum growth. Construction on the final leg reached Bethania on October 23, 1854, and was completed to Lash's store on November 8. The road enticed more settlers, travelers and industry to Bethania. In 1855, the North Carolina legislature voted to acquire $1 million worth of preferred stock in the railroads. Israel George Lash and other Bethanians invested in the North Carolina, Fayetteville and Western Railroad Company, which would come under the directorship of William Alexander Lash, Israel's nephew and Johann Christian Loesch's grandson.

William was already a director in the Piedmont Railroad Company. Israel was a bank president and a commissioner for the Western North Carolina Railroad, and Thomas B. Lash became a commissioner for the Dan River Coalfield Railroad Company—both were appointed by acts of Congress. A few miles to the east of Bethania, and no longer in existence (except as a road name), was Bethania Station.

Activity in preparing the town for its centennial began in earnest. A new store was built on the corner of the stagecoach road, almost a mirror image of Lash's store at the other end of town. In the 1850s, the post office, which was established in 1795 at the Lash store, was moved to Lehman's store.

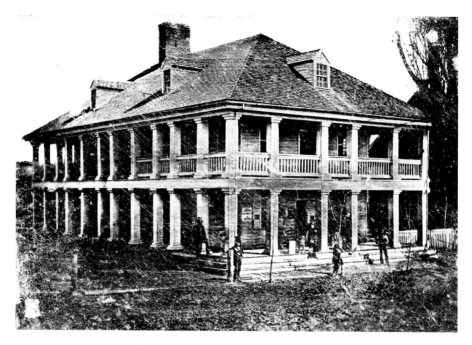

The corner of Main Street and Loesch Lane was the western terminus of the longest and costliest plank road in the South. *Courtesy of the collection of the Moravian Archives, Winston-Salem, North Carolina.*

Shops lined the street; H.H. Butner made guns and rifles. Elias Schaub was a clockmaker, jeweler and silversmith, and he made guns too. There were wagon makers, wheelwrights, cabinetmakers, dressmakers, milliners, shoe shops and a bake oven in the center of town where the Lovefeast buns were made. Wagons once again came through the town daily, bringing supplies and taking produce and other products away.

On June 13, 1859, Bethania celebrated its one-hundred-year jubilee. The houses and church were whitewashed, and interiors were cleaned from top to bottom. Trees and fresh plantings lined the paths from one end of the village to the other. A new enameled pulpit was built by the minister himself, Reverend Siewers, who had learned the cabinetmaking trade as a youth. It was a glorious day, and the celebration lasted well into the night. A diarist wrote, "About 1800 persons had been in attendance, many of whom among the writer did not reach their respective homes until well after midnight." The day had ended with a procession to God's Acre. The pathway was lit by burning pine torches beneath a quiet, starlit night sky. Songs were sung, accompanied by the brass band, and

The Village by the Black Walnut Bottom

A Maximilian Eugene Grunert sketch of Bethania, 1855. *Collection of the Old Salem Museum and Gardens.*

Bethania's one-hundred-year-old history was read. If the men, women and children resting beneath the ground could hear, they must have known that "all seemed to feel that they were in the immediate presence of the Lord." By the end of the year, clouds gathered in the Carolina blue skies. A dark storm hovered above the land and would stay there for years.

A DISTRACTED STATE

Volunteers and several speakers spoke at Lash's store, the object to raise volunteers for the state...At candle light a town meeting was called and met at the School House, where they organized a company of the elderly citizens including near neighbors, as a home company protection, the young men being included. May the Lord watch over us for good, and prevent the threatening of war and restore peace and brotherly love to our country, is my daily prayer.

—*Jacob Siewers*

Bethania's minister, Jacob Siewers, who served the Bethania Moravian Church from 1857 through 1865, continued to document throughout the Civil War entries that reflect a slowly dying southern town:

1862

March 18—The 1ˢᵗ draft among the Militia took place in Forsyth County "the town in consequence was bare of men."

Mar 31—Called at Timothy Spoenhauer—three of his sons are in the Army.

Apr 20—Went to Israel Lash's Negro quarters and baptized three infants. John Pfaff died at Manassas. Timothy Spoenhauer sent three sons to war.

May 21—Visited Pratt—has three sons in the Army—the fourth and youngest has likewise volunteered.

June 14—Called at H.H. Butner, Frank Butner returned from Halifax with Oliver Lehman—Butner is recovering from typhoid fever.

July 13—Went to Micky's schoolhouse—found an empty house.

July 27—My son Joseph being a conscript. Took him to Winston today.

Aug 15—About noon 75 Surry conscripts passed through here.

Aug 19—Held a prayer meeting at Jane Grab's her husband having engaged work in a gun factory in Jamestown—chiefly females present.

Aug 22—Visited Samuel Stauber—he expected to find his son Julius and bring him home [from Richmond] but he had already been buried.

Sept 17—Called at Thomas Schultz, he quite recently lost his son Junius. Went to Henry Schultz, Parmino had been severely wounded. Returned home and stopped at Coller's, they had lost a son recently.

Sept 18—Walked to S.'s, she lost a son at the Camp of Instructions—he died of measles and flux.

Sept 30—Held prayer meeting by request—Alex Grab's and William Stoltz expect to leave in the morning.

Dec 12—Samuel Stauber returned this afternoon with several others from Virginia with their deceased sons.

1863

Feb 15—Oliver Lehman left for the Army. Expects to join the Band in the 33d Regiment of North Carolina Troops.

Feb 16—Alvin Butner, Benj. Chitty, Julius Schaub, James Grabs, Doc. Mock, and others went to Winston to the enrollment.

Feb 24—Sr. George Hauser, m.n. Strupe's son-in-law leaves home tomorrow as a conscript.

Mar 27—At Bethania held a discourse—only ten present.

Apr 8—Gazeil Grab's requested use of my horse—her sister's husband, John Wall, brought back from the Camp at Rappahannock to be buried today.

Apr 11—Baptized the sons of Sr. Mary Shore and Betsy Hauser—the fathers are in the Army.

Aug 30—Benjamin Chitty died of typhus. This is a sore bereavement for us all.

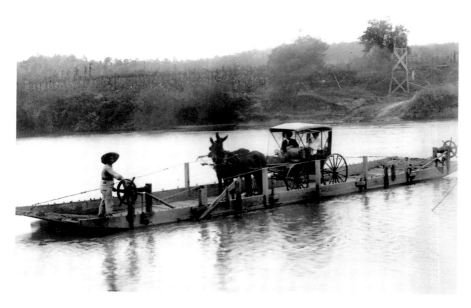

A journey across the Yadkin River. *Photo by J.L. Kapp, circa 1900.*

He was greatly beloved by all who knew him far and near and I shall miss his harmonious and manly voice in our assemblies. [Benjamin Chitty was betrothed to Emma Lehman.]

Sept 19—Visited the widow of Sr. Mary Shore. Her son is at home a paroled prisoner of war. Saw Joseph at Fort Delaware, he was making coffins.

Nov 11—Lienbach's son Edward leaves tomorrow for the Army again.

1864

Bethania Committee Minutes Dec 31, Br. Siewers informed the Committee that application had been made to bury the bodies of Isaac Shore, Sanders Shore, William Shore, and Nerva Hauser on our graveyard who had died in Virginia and were about to be disinterred and brought here. An application from Sr. Tice inquiring what amount of Confederate money the Committee would ask for the burial of a young man named Hine…the Committee has no objection to the four young men as named. As to Sr. Tice's question the Committee unanimously decided they would on no terms take in Confederate money in payment.

1865

The Civil War ended, as far as the eye could see, fields lay fallow, houses empty, and nothing but widows and old men were left in the town and the outlying countryside. Beneath the Carolina blue skies, an eerie quiet settled across the land. By the end of December, the Thirteenth Amendment abolished slavery throughout the United States.

Black Roots

Bethania Roots

That slavery was an intrinsic pattern in the southern way of life cannot be denied. Although annexation has severed Bethania's black roots, slavery is very much a part of Bethania's history, and its black roots go as deep as those of its first white settlers. Bethania's ministers chronicled bits and pieces of African American life throughout the thirteen volumes of *The Records of the Moravians in North Carolina*, but rarely today does an opportunity present itself in which slavery can be seen in detail through the eyes of other Bethania families who experienced it. Thanks to the Internet and the Library of Congress, government records made public, mountains of personal correspondence and newly discovered diaries, we are slowly beginning to be able to trace Bethania's historic black roots. Dr. George Follett Wilson's personal journal between 1828 and 1830, published in 1984 by Evelyn Hubbard Wilson, reflects slavery through the eyes of an abolitionist. Wilson was an outsider, a Yankee by birth, born in Massachusetts, raised in upstate New York and fresh out of a northern medical school, when he arrived in Bethania in May 1828.

Wilson was taken aback by Bethania's rural landscape, farmlands, haphazard cultivation and abject poverty. He was not impressed with Bethania. "This place looks old," he commented, "and the houses have the appearance of decay and require repairing and rebuilding." For the first time in his life, he saw the evidence of slavery. "The Black people are surely degraded and abused. Saw some sold. It is shocking to a person unaccustomed to such scenes. It is not religiously right. It is not just." Bethania needed a doctor, so Wilson established his practice in the town. Within the first few months after his arrival, he fell in love with Sophia Henrietta Hauser, and they married in June 1829. Sophia was one of three children born to Philipina Loesch and Johann Heinrich Hauser Jr., who died in 1821. Philipina married Abraham Conrad in 1822 and bore him a daughter named Julia, who was six years old

George Follett Wilson. *Photo by Evelyn Hubbard Wilson.*

when Sophia and Wilson married. Julia Jones's father, Abraham Conrad, was a wealthy landowner and the widower of one of George Hauser's daughters, as well as related through blood ties to Johann Christian Loesch [Lash].

Wilson boarded with Loesch for the first few months that he was in Bethania. "In company this morning was the youngest son of Christian Lash," Wilson wrote. "He is possessed of an impetuous disposition, a strong tendency of affection in his manners, unfeeling and overbearing in his dealings, austere and unattractive in his manner of conversation, proud, haughty and disdainful." Wilson did not have a good first impression of the young man, who was Israel George Lash, born in 1810 and only eighteen at their first meeting. "I will venture to say there will be few people to love or respect him," Wilson added, "and none to place real confidence in his integrity." Wilson, however, would later change his mind.

Israel's father, Johann Christian Loesch, held shares in the first state bank of North Carolina and its branch in Salem. The bank was established in 1815 and was handled by Carl Bagge, Christian Blum and Emanuel Schober. Blum took over as agent in 1816. There was a scandal of sorts when $10,000 in

bank notes mysteriously burned, "as Christian Blum carried on his business as agent of the Cape Fear Bank," in a fire in early 1827. Blum became debtor to C. Bagge, Jacob Blum, Christian Lash and Jacob Conrad. While the terms of the settlement were not listed, Johann Christian Loesch died in 1844, and Israel George Lash became the cashier of the Cape Fear Bank in 1847. This was about the same time that railroads and plank roads were stirring the nation, and Lash's money helped to finance the Fayetteville and Western Plank Road Company, along with that of the Conrads, Hausers, Joneses and Wilsons, among other Bethania and Salem families. The labor was supplied by their slaves.

The first Bank of Cape Fear did not remain open during the Civil War; however, it became the steppingstone for the new First National Bank of Salem. Israel Lash, as president, reopened the bank in 1866 and hired his nephew, William Lemly, as cashier. Lemly had just returned from the war the previous year. After Lash died in 1878, Lemly established a new bank in Winston under the charter of Wachovia National Bank on June 16, 1879. Lemly took over as president after Wyatt Bowman died in 1882. As for Israel, he served as congressman and became a state delegate to the Constitutional Convention in 1868 upon North Carolina's readmission into the Union after the Civil War. He served as a Republican representative to both the fortieth and forty-first Congresses. His grave marker is the tallest and largest in the Bethania Moravian Church's God's Acre Cemetery.

Israel Lash, like George Wilson, became one of the first five commissioners appointed by the Act to Incorporate the Town of Bethania in 1839. The secret as to whether the actual ratification of the bill occurred may rest in the fact that Wilson supposedly did not join the Bethania Moravian Church, per family sources, yet he is mentioned by the Bethania diarist as being a leader in the town for many years. Wilson moved his family to Yadkinville in 1853 and died there in 1857.

While it was not specified why Wilson moved away from Bethania, his medical practice was successful and he and Sophia had eight children, seven of whom grew up in Bethania. Wilson eventually embraced slavery by taking on Nancy, a spinner, in 1830, and later he built slave houses on his in-town property and extended his holdings.

Wilson's young sister-in-law, Julia Conrad, was born in 1823. She was related by birth to the Hauser, Lash and Conrad bloodlines, and she grew up privileged. She attended Salem Female Academy, studied many fine arts and played the piano. Julia married Dr. Beverly Jones in 1843 and bore ten children. She kept diaries, collected recipes and was a devoted wife and mother of a large family. In 1846, Architect Dabney Cosby was commissioned

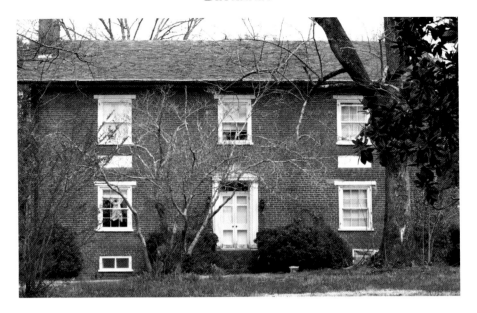

The Dr. Beverly Jones Plantation House, built by architect Dabney Cosby in 1847. *Photo by Bowman Gray.*

to design a house on land lying between her grandfather's and father's land. The house was completed in 1847. The house was impressive and needed an equally impressive name, so a plantation called Oak Grove came into being.

PLANTATION LIFE ON OAK GROVE

The ranks of negro ex-slaves are rapidly thinning out, but, scattered here and there among the ante-bellum families of the South, may be found a few of these picturesque old characters. Three miles north of Bethania, the second oldest settlement of the "Unitas Fratrum" in Wachovia, lies the 1500 acre Jones plantation. It has been owned for several generations by the one family, descendants of Abraham Conrad. Conrad's daughter, Julia, married a physician of note, Dr. Beverly Jones, whose family occupied the old homestead at the time of the Civil War. Here, in 1856, was born a negro girl, Betty, to a slave mother.

—*Mary A. Hicks*

Betty Cofer, was born into slavery at Oak Grove. She knew Bethania both as a slave and, later, as a free woman of color. Her oral history, taken by

The Village by the Black Walnut Bottom

Mary A. Hicks through the Federal Writers' Project of the Works Progress Administration (WPA) in 1937, paints vivid scenes that reflect Bethania's rich black cultural identity. For many years, Betty's oral history and its significance to Bethania were unknown, had been misidentified and were attributed to another oral historian. The Internet has also opened the possibility that Betty's last name was not Cofer but Koger, as descendants and others who have memories of her before her death claim.

Hicks begins the interview describing Bethania at the end of the Depression. The Jones Plantation actually lies one mile to the north of Bethania and a half mile above Loesch Lane:

> *Here, today, under the friendly protection of this same Jones family, surrounded by her sons and her sons' sons, lives this same Betty in her own little weather-stained cottage.*
>
> *Encircling her house are lilacs, althea, and flowering trees that soften the bleak outlines of unpainted outbuildings. A varied collection of old-fashioned plants and flowers crowd the neatly swept dooryard. A friendly German-shepherd puppy rouses from his nap on the sunny porch to greet visitors enthusiastically.*
>
> *In answer to our knock a gentle voice calls, "Come in." The door opens directly into a small, low-ceilinged room almost filled by two double beds. These beds are conspicuously clean and covered by homemade crocheted spreads. Wide bands of hand-made insertion ornament the stiffly starched pillowslips. Against the wall is a plain oak dresser. Although the day is warm, two-foot logs burn on the age-worn andirons of the wide brick fireplace. From the shelf above dangles a leather bag of "spills" made from twisted newspapers.*

In 1937, Betty's cottage was situated on an unimproved roadway that is now Bethania–Rural Hall Road. The landscape was bucolic, rural; there were no subdivisions and no golf course. The shell of this cottage still stands. There are other remnants of former slave houses that dot the landscape surrounding Bethania, and although they can't be seen from the roadways, they are there nonetheless. Some of the buildings have been recycled and are a part of residences. Some stand as testimony to their long-ago residents. Ghost shadows dance in the sunlight; streams of light that even a seasoned photographer can't make appear in photographs. The shadows are a dividing line between darkness and light, between black and white. Betty opens eyes to the color line from two places in time—the post-Depression era in which she lived and the pre–Civil War South.

In a low, split-bottom chair, her rheumatic old feet resting on the warm brick hearth, sits Aunt Betty. Her frail body stoops under the weight of four-score years but her bright eyes and alert mind are those of a woman thirty years younger. A blue-checked mop cap covers her grizzled hair. Her tiny frame, clothed in a motley collection of undergarments, dress and sweaters, is adorned by a clean white apron. Although a little shy of her strange white visitors, her innate dignity, gentle courtesy, and complete self possession indicate long association with "quality folks."

Her [Betty's] speech shows a noticeable freedom from the usual heavy negro dialect and idiom of the deep South. "Yes, Ma'am, yes, Sir, come in. Pull a chair to the fire. You'll have to 'scuse me. I can't get around much, 'cause my feet and legs bother me, but I got good eyes an good ears an' all my own teeth. I aint never had a bad tooth in my head. Yes'm, I'm 81, going on 82. Marster done wrote my age down in his book where he kep' the names of all his colored folks. Muh (Mother) belonged to Dr. Jones but Pappy belonged to Marse Israel Lash over yonder (pointing northwest)…Yes'm, I remember Marse Israel Lash, my Pappy's Marster, he was a low, thick-set man, very jolly an' friendly. He was real smart an' good too, 'cause his

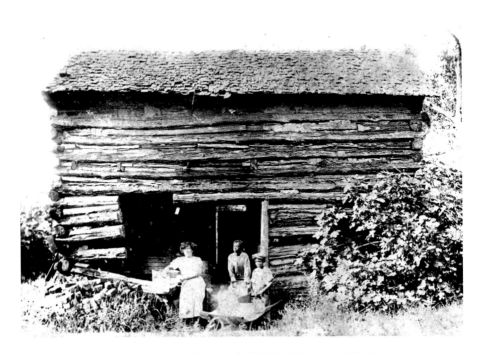

A haunting picture of slavery days. *Courtesy of Old Salem Museums and Gardens.*

The Village by the Black Walnut Bottom

colored folks all loved 'im… Young'uns always went with their mammies so I belonged to the Joneses.

The first Dr. Beverly Jones was a son of Gabriel Remi de Martin Jones, a wealthy Virginia planter. Julia Jones, Beverly's wife, was the daughter of Abraham Conrad and Philipina Loesch Hauser Conrad and the granddaughter of Johann Christian Loesch/Lash and George Hauser. The intermarriage between the Conrad, Hauser, Loesch/Lash families was extremely advantageous. All were wealthy and owned vast amounts of property in the area surrounding Bethania, as well as homes and businesses in the town and elsewhere.

Some of Lash's property extended from what is now Loesch Lane and bordered the Jones Plantation, a stately brick house surrounded by barns, cabins and numerous outbuildings. Marse Israel Lash was the son of Johann Christian Lash's third marriage to Anna Maria Seitz. Johann's first two marriages were to sisters from the Hauser family, Gertraut (Gertrude) and Johannna. George Houser was also the former father-in-law of Abraham Conrad, whose first wife died in childbirth. Johann Heinrich Hauser Jr., father of Henrietta Hauser, was George Hauser Sr.'s son. The Jones family records are extensive and show the deep relationship between the families. Julia also kept tedious notes on the day-to-day operation of Oak Grove. Baking was done in the early morning and was prepared the evening before. A typical day began before 4:00 a.m. and lasted well into darkness. Betty recalled:

Muh and Pappy could visit back and forth sometimes but they never lived together 'til after freedom. Yasm, we was happy. We got plenty to eat. Marster and old Miss Julia (Dr. Jones wife, matriarch of the whole plantation) was mighty strict but they was good to us. Colored folks on some of the other plantations wasn't so lucky. Some of 'em had overseers, mean, cruel men. On one plantation the field hands had to hussle to git to the end of the row at eleven o'clock dinner-time 'cause when the cooks brought their dinner they had to stop just where they was and eat, an' the sun was mighty hot out in those fields. They only had ashcakes (corn pone baked in ashes) without salt, and molasses for their dinner, but we had beans an' grits an' salt an' sometimes meat.

Yes'm, there was a crowd of hands on the plantation. I mind 'em all an' I can call most of their names. Mac, Curley, William, Sanford, Lewis, Henry, Ed, Sylvester, Hamp, an' Juke was the men folks. The women was Nellie, two Lucys, Martha, Nervie, Jane, Laura, Fannie, Lizzie, Cassie, Tensy, Lindy, an' Mary Jane. The women mostly, worked in the house.

Wash day. *Courtesy of Old Salem Museums and Gardens.*

There was always two washwomen, a cook, some hands to help her, two sewin' women, a house girl, an' some who did all the weavin' an' spinnin'. The men worked in the fields an' yard. One was stable boss an' looked after all the horses an' mules.

84

The Village by the Black Walnut Bottom

A spinning shed on the Dr. Beverly Jones Plantation. *Photo by Bowman Gray.*

Betty's statement on slave names connects several to a contract in 1858 drawn up by Abraham Conrad between Beverly and Julia Jones:

> *From Abraham Conrad to Beverly and Julia Jones for consideration of Love and $1000 do following slaves to wit, Jack, Mat, Duke, John, Adam, Cole, Levin, Sandford, Joe, Sandy, Wesly, Ed, Sylvester, Calvin, Lucy (Speace), Lucy (Briggs), Nance, Linda and her child Mary, Tensy and her children Bet and Mary, Martha and her children Fanny, Minerva and her child Lizzy, Paulina, and Frances.*

By 1830, census records show Loesch holding thirty slaves, Abraham Conrad fifteen slaves, Jacob Conrad twenty-six slaves and John Conrad twenty-one slaves. The buying and selling of slaves was common practice and sometimes went unrecorded because slave traders frequented the rural area surrounding Bethania. George Wilson noted in 1830:

> *Have attended today on one of those who deals in Negroes, buy and sell. I saw poor fellows with downcast looks dreading the moment they had to leave the place of their nativity and all relations. I cannot yet believe this is just or right and if it was free from injustice, it is mean and vile employment.*

The plank road had brought posterity to Bethania and slave labor was a critical component in operating the farms and plantations. The Jones family papers document the building of Oak Grove, including Julia Jones's insistence of having a separate kitchen with a large fireplace and both indoor and outdoor bake ovens. The summer kitchen, as the outdoor kitchen was called, was built with the same brick as the house. Mat, Giles, George, Jesse and Nelson were just a few of the slaves who made the brick.

By 1850, what records did exist pointed to the fact that Bethania, even within the core town, had large slaveholdings. A ledger for slaves and taxables in the Bethania District lists slave owners, and of the 257 recorded, fewer than half list the slave's name and age. Israel George Lash and Thomas B. Lash had 127 slaves living in their slave quarters in town. These slaves supplied the labor for their many enterprises. In another file, a letter dated 1857 from one of Julia Jones's stepbrothers states:

> I forgot to tell you the Negro Lewis whom I got from your father—before leaving for Kentucky I had two offers for him—from your step-father and from Uncle Israel Lash but mother decided the purchase. I am aware of the fact that Grandfather George Hauser sold 300 Negroes to Jacob Conrad.

This is a conceivable statement. George Hauser had been purchasing slaves since the eighteenth century. Records of slaves, their names and vital statistics such as birth, death and, when allowed, marriage are rare. Early laws were loose and records sporadic. A child may have been born into slavery, but he or she did not immediately become a taxable. Records of slaveholdings were not always recorded, particularly for infants and young children. Even Betty remembered the practice of slave trafficking continuing some thirty years after Wilson's observation. She recalled:

> Yes'm, I saw some slaves sold away from the plantation, four men and two women, both of 'em with little babies. The traders got 'em. Sold 'em down to Mobile, Alabama. One was my pappy's sister. We never heard from her again. I saw a likely young feller sold for $1500. That was my Uncle Ike. Marse Jonathan Spease bought him and kep' him the rest of his life.

By the late 1850s, Abraham Conrad's ill health slowly forced him to relinquish his prosperous gristmill, which was a short distance away, to his son-in-law, Beverly Jones. Betty remembers the mill and the expansive Jones plantation during her slavery days:

The Village by the Black Walnut Bottom

We raised our own flax an' cotton an' wool, spun the thread, wove the cloth, made all the clothes. Yes'm, we made the mens' shirts an' pants an' coats. One woman knitted all the stockin's for the white folks an' colored folks too. I mind she had one finger all twisted an' stiff from holdin' her knittin' needles. We wove the cotton an' linen for sheets an' pillow-slips an' table covers. We wove the wool blankets too. I use to wait on the girl who did the weavin' when she took the cloth off the loom she done give me the 'thrums' (ends of thread left on the loom.) I tied 'em all together with teensy little knots an' got me some scraps from the sewin' room and I made me some quilt tops. Some of 'em was real pretty too! (Pride of workmanship evidenced by a toss of Betty's head.)

Miss Julia cut out all the clothes for men and women too. I 'spect her big shears an' patterns an' old cuttin' table are over at the house now. Miss Julia cut out all the clothes an' then the colored girls sewed 'em up but she looked 'em all over and they better be sewed right! Miss Julia bossed the whole plantation. She looked after the sick folks and sent the doctor (Dr. Jones) to dose 'em and she carried the keys to the storerooms and pantries... All our spinnin' wheels and flax wheels and looms was hand-made by a wheelwright, Marse Noah Westmoreland. He lived over yonder (a thumb indicates north). Those old wheels are still in the family. I got one of the

Betty's spinning wheel. *Courtesy of Inge Robinson.*

flax wheels. Miss Ella done give it to me for a present. Leather was tanned an' shoes was made on the place. 'Course the hands mostly went barefoot in warm weather, white chillen too.

We had our own mill to grind the wheat and corn an' we raised all our meat. We made our own candles from tallow and beeswax. I 'spect some of the old candle moulds are over to "the house" now. We wove our own candlewicks too. I never saw a match 'til I was a grown woman. We made our fire with flint an' punk (rotten wood). Yes'm, I was trained to cook an' clean an' sew. I learned to make mens' pants an' coats. First coat I made, Miss Julia told me to rip the collar off, an' by the time I picked out all the teensy stitches an' sewed it together again, I could set a collar right! I can do it today, too! (Again there is manifested a good workman's pardonable pride of achievement).

Many antebellum Southern stories reflect a kinship and friendship between slaves and their white master's family. When we look backward through time, we often see the world through a different light. Certainly, there was ill treatment of slaves, even in the Moravian towns. As the winds of war escalated, fear of slave uprisings was tantamount. We know, however, that the Civil War, like the War of Regulation and the Revolutionary War, changed the American way of life. By 1860, the halcyon days of plantation life were holding on by a thread. This is evidenced throughout the detailed plantation records kept by Dr. Beverly Jones and his wife, Julia, particularly after the Emancipation Proclamation was publicized and during the period between 1863 and 1865. These documents and family letters have been preserved in Wilson Library at Chapel Hill. Three of the Jones boys joined the army—one became a prisoner of war, one was seriously injured in battle and one suffered for months from a grave illness.

But life went on during this time, and Julia recorded everything that transpired almost daily. Each day of the week had specific tasks, and Julia ran Oak Grove like a finely honed piece of machinery while raising her ten children. Miss Ella was the seventh child to be born to Julia. She, of course, was privileged too. Her room on the second floor was small by today's standards but was befitting of a wealthy plantation owner's child. Ella and Betty were almost the same age when Betty was given to Miss Ella:

I was lucky. Miss Ella was a little girl when I was borned and she claimed me. We played together an' grew up together. I waited on her an' most times slept on the floor in her room. Muh was cook an' when I done got big enough I helped to set the table in the big dinin' room. Then I'd put on a clean white apron an' carry in the victuals an' stand behind Miss Ella's chair. She'd fix

me a piece of somethin' from her plate an' hand it back over her shoulder to me (eloquent hands illustrate Miss Ella's making of a sandwich). I'd take it an' run outside to eat it. Then I'd wipe my mouth an' go back to stand behind Miss Ella again an' maybe get another snack.

We raised our own flax an' cotton too an' stood by her—but one time. That was when we was little girls goin' together to fetch the mail. It was hot an' dusty an' we stopped to cool off an' wade in the "branch." We heard a horse trottin' an' looked up an' there was Marster switchin' his ridin' whip an' lookin' at us. "Git for home you two, and I'll tend to you," he says an' we got! But this time I let Miss Ella go to "the house" alone an' I sneaked aroun' to Granny's cabin an' hid. I was afraid I'd get whupped! 'Nother time, Miss Ella went to town an' told me to keep up her fire whilst

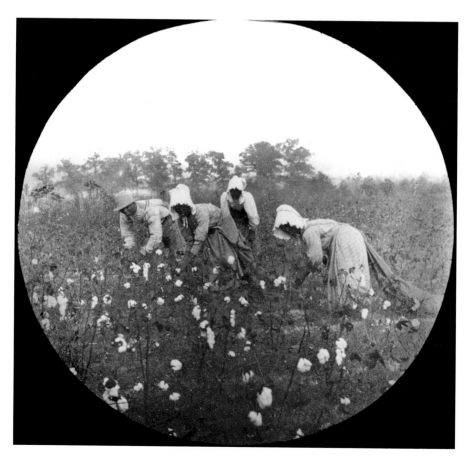

A typical Southern scene. *Collection of Old Salem Museums and Gardens.*

she was away. I fell asleep on the hearth and the fire done burnt out so's when Miss Ella come home the room was cold. She was mad as hops. Said she never had hit me but she sure felt like doin' it then.

As abolition sentiments increased, so did tensions over owning slaves. Laws became more explicit, and because of laws governing slavery prior to the Civil War, it was illegal to teach slaves to read or write. Salem did not permit ownership of slaves within the town, although it did establish a separate Negro congregation and kept a separate diary for them. Bethanians, however, followed their own rules and were the first to establish a Negro congregation as early as 1802. In January 1847, the Bethania church committee "approved that an effort should be made to bring religious instruction to Negro children through storytelling and talks." The first official church graveyard for Bethania's slaves was consecrated at the same time upon the death of Milly, a slave belonging to Lash. A fence was built around the graveyard, and $0.75 was collected for each grave by the owners of the Negroes. A gravestone was to be procured with at least the name and date of death marked. A diarist noted, "If a grave is made it is to be reported to the pastor who than goes and points to where the grave should be dug. If a member is not willing to pay for his Negroes grave, it will be made anyway."

Soon after Stokes County was reapportioned in 1849, adding Forsyth County, a church—a small log structure—was built for Bethania's Negro population and was dedicated on October 6, 1850. This did not come without a great deal of work on the part of Bethania's Pastor Hagen in securing permissions, land, labor and finances. Men from Bethania, along with slaves, completed the work. Another log building, called the schoolhouse, was situated between the old Conrad mill and the Negro graveyard at Dr. Jones's. When asked about her schooling, Betty responded:

Yes'm, I'm some educated. Muh showed me my a-b-abc and my numbers and when I was fifteen I went to school in the log church built by the Moravians. They give it to the colored folks to use for their own school and church. (This log house is still standing [1937] near Bethania.) Our teacher was a white man, Marse Fulk. He had one eye, done lost the other in the war. We didn't have no colored teachers then. They wasn't educated. We 'tended school four months a year. I went through the fifth reader, the "North Carolina Reader." I can figure a little an' read some but I can't write much 'cause my fingers 're all stiffened up. Miss Julia use to read the bible to us an' tell us right an' wrong, and Muh showed me all she could an' so did the other colored folks. Mostly they was kind to each other.

The Village by the Black Walnut Bottom

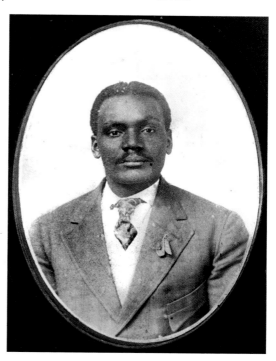

Lonnie Hauser. *Courtesy of Old Salem Museums and Gardens.*

For the most part, Bethanians treated their slaves with kindness. Pastor Hagen noted in 1848:

> *During the course of these months the efforts to instruct the Negroes at this place and their children in divine truths were continued. It does not seem to go so well as might be wished, since some of the masters are not properly interested in the matter. The dear sisters do not let this distract them but continue faithfully and industriously to instruct the children.*

North Carolina seceded from the Union on May 20, 1861. Because of the deeply rooted Northern ties in what was once Wachovia and was now a melting pot of many faiths, church and state had to separate. In the true sense for this part of the country, the war became one that pitted brother against brother and family against family. The Moravian Church—its first American roots planted in Georgia, then Pennsylvania and, finally, firmly buried in North Carolina soil—proceeded as the Moravians had always done in the past. Even the one Moravian province was now split into two. Southern parents of young men who were attending the Moravian school in Pennsylvania were asked if they wished for their sons to be returned home.

"No," the parents said and life went on. But it changed nonetheless, often at the stroke of the hour because the winds of war blew in many directions. Before the end of the Civil War, the plank road lay in ruins; some parts had been washed away by wind and rains, others by human cause. The young men of the town had been carried off by the dark clouds of war, and a country was left in mourning. When asked if she ever saw soldiers during the Civil War, Betty replied:

> *Yes'm, we saw Yankee soldiers* [Stoneman's Calvary in 1865]. *They come marchin' by and stopped at "the house." I wasn't scared 'cause they was all talkin' and laughin' and friendly but they sure was hongry. They dumped the wet clothes out of the big wash-pot in the yard and filled it with water. Then they broke into the smoke-house and got a lot of hams and biled 'em in the pot and ate 'em right there in the yard. The women cooked up a lot of corn pone for 'em and coffee too. Marster had a barrel of "likker" put by an' the Yankees knocked the head in an' filled their canteens. There wasn't ary drop left.*

The Yankees began advancing in early April 1865. On Monday, April 10, during an early candlelight meeting, news came that the Yankees were in town. A Bethania diarist wrote, "When I went in front of the parsonage I perceived the street full of Calvary and heard that the town was in possession of General Stoneman's command estimated at 4 or 5 thousand horsemen." Sometime during this frightful week, a fire was lit north of the town, and the old Conrad mill burned to the ground. Betty remembered:

> *When we heard the soldiers comin' our boys turned the horses loose in the woods. The Yankees said they had to have 'em an' would burn the house down if we didn't get 'em. So our boys whistled up the horses an' the soldiers carried 'em all off. They carried off ol' Jennie mule too but let little jack mule go. When the soldiers was gone the stable boss said, "If ol' Jennie mule once gits loose nobody on earth can catch her unless she wants. She'll be back!" Sure enough, in a couple of days she come home by herself an' we worked the farm jus' with her an' little jack.*

Within the central town of Bethania, less than a mile from the Jones Plantation, the scene was reminiscent of the end of the Revolutionary War, when both the American and English troops passed through town daily. During Easter week 1865, the diarist recalled, "General Stoneman made his quarters with Br. Elias Schaub, and after remaining some three hours to rest

The Village by the Black Walnut Bottom

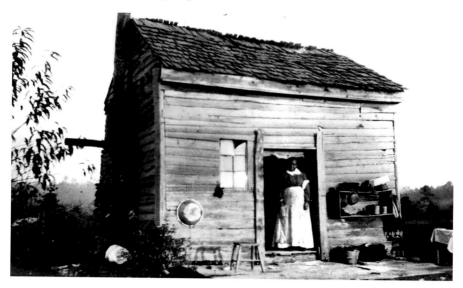

A former slave named Lucy. *Courtesy of Old Salem Museums and Gardens.*

and partake of refreshment, the whole body moved on towards Salisbury." Schaub's home and shop stood just two lots away from the church, the second lot before the corner property. Schaub was also a gun maker and silversmith, so perhaps Stoneman spent his time wisely in Bethania. Throughout the week, soldiers returned, stealing horses and food, but they left Schaub's horses alone. General Stoneman's raiders wreaked havoc, and then on Thursday, General Lee's troops came through from Virginia after the surrender, "calling nearly at every house for something to eat." For days, as many as four or five hundred men walked or rode through the town. As in the previous wars, it was difficult for Bethania's people to refuse giving them sustenance. As word of the surrender spread through the Negro population. Betty recalled:

> *Some of the colored folks followed the Yankees away. Five or six of our boys went. Two of 'em travelled as far as Yadkinville but come back. The rest of 'em kep' goin' an' we never heard tell of 'em again.*
>
> *I saw General Robert E. Lee, too. After the war he come with some friends to a meeting at Five Forks Baptist Church. All the white folks gathered 'round an' shook his hand an' I peeked 'tween their legs an' got a good look at 'im. But he didn't have no whiskers, he was smooth-face! (Pictures of General Lee show him with beard and mustache.)*

Like Jennie the mule, Bethania's men began to return home—some in wagons, their bodies to be buried in the white God's Acre. On one particular day, the pastor sadly recorded four burials. Others returned with their minds and bodies broken by the nightmares of death and destruction. Others took on new businesses and tried to rebuild the town that now, as one young man wrote, "lay in waste with no one but women and old men." Later, Bethania's pastor lamented, "I have no material left to build up a congregation with." During the course of the previous decades, young people had left for the Methodist camp meetings and stayed there because, as one young man noted, "no one had taken notice on the church's part, so they joined and were gone for good as far as we [church] was concerned."

George Bahnson's words perhaps describe best what transpired:

> *The fearful civil strife of a once united people had been going on for years, devastating portions of our land, decimating its once highly favored indwellers, sowing broadcast mourning and lamentations, sundering the most sacred ties uniting man to man, interfering most fatally with the happiness of numberless families, depriving parents of children, children of parents, wives of their husbands, and reducing smiling landscapes into howling deserts.*

RECONSTRUCTION AND AFTERMATH

The old home place was not the same, and within a few months after departing Northern and Southern troops had passed through Bethania, another terrible sickness swept through the village. This could have simply been a seasonal episode like those that had occurred during past years, or it could have been transmitted by one of the war-torn stragglers who were still coming through the town. Julia Jones communicated in a letter to a stepbrother in June 1865:

> *Since I wrote you one month ago, a terrible sickness came. There were at times ten in the bed at one time. A few weeks after that Alex died, Jo died, Nance's youngest son, then William, Fanny's son, just one week after Jack was taken too, and in a very short time. One of Tensey's daughters afterwards her infant Nellie also one of her girls, France, Nance's youngest child sickened and died so soon also several infants. I never did go through such troubles. All my help was gone. I hardly knew where to begin with the work. The field hands and all were sick, those that were not in bed*

The Village by the Black Walnut Bottom

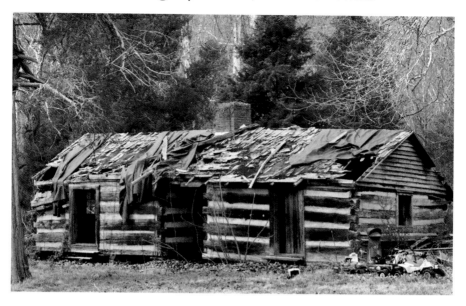

A Dr. Beverly Jones Plantation slave cabin. *Photo by Bowman Gray.*

*were not able to do anything. Four children are all that escaped. It was
yet very difficult to procure help and I got some white persons to assist me.
One was taken sick and went home. The Negroes do not seem too willing
to stay. They all wish to rent land and to go to housekeeping. I think after
a trial they will be willing to go to regular work again. How anyone is
situated as I with five small children still at home, the youngest not quite
two is to do, I am unable to say. Much sick up around us but nowhere
have so many died as here.*

The church records between 1857 and 1865 are a mute testimony
to the decline of Bethania's people. In 1857, there were 119 children,
132 communicants and 63 non-communicants—314 total. In 1865,
the records showed 36 children, 126 communicants and 18 non-
communicants for a total of 180. Neither list included those who did
not belong to the church or the Negro population. Emancipation came
quietly in the night. One day you were a slave and the next day you
were free. A loose-leaf sheet inserted into the Salem African American
Church diary, dated December 31, 1865, explains:

*The colored division of the church has passed through a severe ordeal. The
sudden change from a state of servitude to freedom could not but have a*

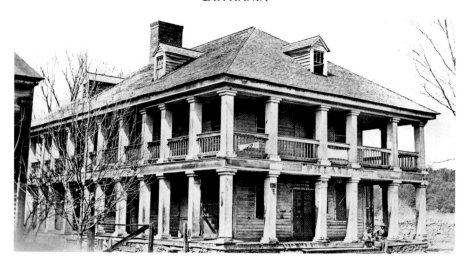

The second level of the Lash store where slaves worked in the tobacco factory. *Courtesy of the collection of the Moravian Archives, Winston-Salem, North Carolina.*

very great influence upon those affected by it. Although of those connected with the church a limited number only left this neighborhood, yet it would appear as if the restlessness created by the emancipation and the desire to find comfortable homes of their own selection had withdrawn attention measurably from the care of their souls.

The reconstructing of lives was happening everywhere, not just in the South. It took years to plow the fields of destruction and war on American soil. The fields surrounding Bethania's countryside were plowed under and many were planted with tobacco. Tobacco was always an important commodity for Bethania, and the Lash Cigar factory above the store was operated by slave labor. What happens, though, when one day labor is free and the next day it is not? The Reconstruction era in Bethania eventually brought hope and promise. There were few former slaves who had been given land or a monetary settlement. Still, there was something greater—a sense of family and a sense of place. Betty never severed her ties with her former masters:

Yes'm, when we was freed Pappy come to get Muh and me. We stayed around here. Where could we go? These was our folks and I couldn't go far away from Miss Ella. We moved out near Rural Hall [some three miles from Bethania] *an' Pappy farmed, but I worked at the home place a lot. This is home to us…When I was about twenty-four Marse R.J.*

The Village by the Black Walnut Bottom

Reynolds come from Virginia an' set up a tobacco factory. He fetched some hands with 'im. One was a likely young feller, named Cofer [Koger], *from Patrick County, Virginia. I liked 'im an' we got married an' moved back here to my folks. We started to buy our little place an' raise a family. I done had four chillen but two's dead. I got grandchillen and great-grandchillen close by. Yes'm, I been here a right smart while. I done lived to see three generations of my white folks come an' go, an' they're the finest folks on earth. There used to be a reglar buryin' ground for the plantation hands. The colored chillen used to play there but I always played with the white chillen. (This accounts for Aunt Betty's gentle manner and speech.) Three of the old log cabins* [slave cabins] *is there yet. One of 'em was the "boys cabin"* [house for boys and unmarried men]. *They've got walls a foot thick an' are used for store-rooms now.*

Reynolds began his business in 1874 and became one of the most significant tobacco giants in the country. Bethania at one time was widely known as the seat of the extensive cigar factory of Lash & Bros. It closed toward the end of the Civil War due to the end of slave labor. Tobacco was still a viable commodity, and O.J. Lehman & Co. built a new factory and began to produce plug and twist. It produced about 100,000 pounds

Close-up of the boys slave cabin. *Photo by Bowman Gray.*

yearly. Nearby was the factory of C.H. Orender, which made about 75,000 pounds of the same. Someone wrote of Thelma Small, "Many times she heard of her grandfather [Koger] as a man of stern rigid character. He was quite often called a loner having come to this country from Patrick County." The factories were filled with former slaves who had returned to the area or who were willing to work for any type of payment. Slowly, ever so slowly, Bethania, along with the rest of the country, began to recover. Life was good again, or at least amicable. Betty said:

> *When we talk about the old home place* [the Jones residence] *we just say "the house" 'cause there's only one house to us. The rest of the family was all fine folks and good to me but I loved Miss Ella bettern any one or anythin'. I just asked her an she give it to me or got it for me somehow. Once when Cofer* [Koger] *was in his last sickness his sister come from East Liverpool, Ohio, to see 'im. I went to Miss Ella to borrow a little money. She didn't have no change but she just took a ten dollar bill from her purse an' says "Here you are, Betty, use what you need and bring me what's left."*

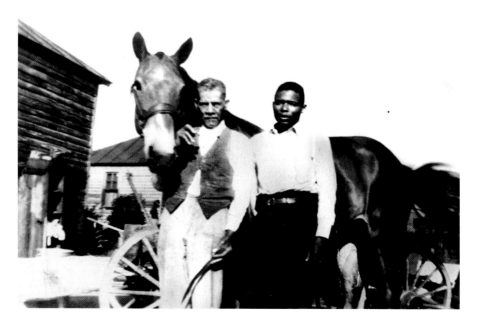

In the early 1900s, a colored fair was held in the old schoolhouse in Bethania that sat across the road from the church on Bethania–Rural Hall Road. *Courtesy of Old Salem Museums and Gardens.*

The Village by the Black Walnut Bottom

Miss Ella died two years ago [1935]. *I was sick in the hospital but the doctor come to tell me. I couldn't go to her bury'n'. I sure missed her. (Poignant grief moistens Betty's eyes and thickens her voice.) There wasn't ever no one like her. Miss Kate an' young Miss Julia still live at "the house" with their brother, Marse Lucian [all children of the first Beverly Jones and "old Miss Julia"] but it don't seem right with Miss Ella gone. Life seems dif'rent, some how, 'though there' lots of my young white folks an' my own kin livin' round an' they're real good to me. But Miss Ella's gone!*

Ella wrote in a letter dated December 12, 1897:

I think of you very often and all of my recollections of my childhood home are with you and brothers and sisters. My first cousins from father's side are nearly all gone. Cousin Amanda and Martha Conrad are all that are living. Uncle Thomas's daughter, Lilly Lash, was appointed one of a committee to make a collection for the graveyard fence. That is why she is asking family members to donate money for the fence. She is a good Moravian, a worker

The Dr. Beverly Jones family graveyard, located a half mile from the town. The graveyard continues to be cared for by descendants and is located in a private area, atop a gentle rolling hill, beneath tall cedar trees and a Carolina blue sky. Surrounding the family plot is a larger enclosed fence line. *Photo by Bowman Gray.*

in the Sunday School, and to crown all a very handsome woman. The other girls, Sallie and Cornelia are married. The fence was built by Easter. All the male members got together and it did not take them long to get it done.

In 1875, the Bethania Negro Church was reformed by the Reverend A.T. Goslen into the AME Zion Connection. Goslen was the first colored preacher for the church, and with the help of Anderson Love, Benjamin Biting, Lydia Washington, Thomas Miller and Joseph Shouse, the church once again began to grow in membership. Jacob Lofton Lash, who was born in 1857 near Old Town and moved near Bethania as a young boy, joined the church. Years later, he was ordained as a minister and continued to serve the church for many years. As the records and diaries kept by the Moravians were translated from German into English during the past century, the rich African American heritage in Wachovia became known. Reverend Lash set about to capture the history, but so much of Bethania's records were lost and many have not yet been translated.

After emancipation, many of Bethania's former slaves remained and settled in the area that came to be known as Washington Town. The first freed Bethania slaves to own property lived here. Names recorded on the 1822 2,500¾-acre plat map are George, Turner, William and John Washington. This land is located in the southeast section, near the New Hope Methodist Church. Nearby is the Oak Grove Schoolhouse, as it came to be known, built about 1910; it served Bethania's black community until it was sold in the early 1950s. Many names on the school's register follow the same surnames as white Bethania residents. The schoolhouse was eventually sold and later belonged to Beulah G. Miller, who inherited it from her late husband. The schoolhouse was restored through community effort and support, and in 2002, it was listed on the National Register of Historic Places.

J. Loften Lash, whose house addition was partially constructed from the old Lash store building material, lived around the bend from the church. The Glen-Martin House, built by India Glen Martin's parents about 1900, also stood nearby. These properties were the only two African American homes included in Bethania's 1991 National Register Historic District boundary increase; however, there are other sites considered to be early African American houses that sit on Bethania–Rural Hall Road and elsewhere. Their significance has yet to be researched, and the buildings are in jeopardy of being torn down.

Not too far away on Bethania–Rural Hall Road, on one winter's evening several years ago, in the midst of a severe ice storm, a small house was destroyed by a truck that skidded on the icy road. The house belonged to a man named Ali Shabazz, a descendant of former slaves. Georgia Byrd, Ali's sister, lived in the vicinity too. Their land had been in the family since

slavery days, and their grandparents told them how other relatives were buried beneath the property's soil. According to Betty:

> *After freedom we buried out around our little churches but some of th' old grounds are plowed under an' turned into pasture cause the colored folks didn't get no deeds to 'em. I won't be long 'fore I go too but I'm gwine lie near my old home an' my folks.*

In 2006, the last of the historic Freedmen's Community was annexed into the city of Winston-Salem. In October 2008, a demolition order to tear down Ali Shabazz's home was delayed and a historic marker commemorating the Freedmen's Community was placed on Bethania–Rural Hall Road and Turfwood Drive. Although Shabazz's building was condemned, efforts are being made to save it, as well as other property in the neighborhood.

Since 1937, Bethania's surrounding landscape has changed dramatically, yet Betty Koger's oral history has given back to some of us those roots that were severed by annexation, a sense of peace and possibly even closure:

> *Goodday, Ma'am. Come anytime. You're welcome to. I'm right glad to have visitors 'cause I can't get out much."* A bobbing little curtsy accompanied Betty's cordial farewell. *Although a freed woman for seventy-one years, a property owner for half of them and the revered head of a clan of self-respecting, self-supporting colored citizens, she was still, at heart, a "Jones negro." All of the distinguished descendants of her beloved Marse Beverly and Miss Julia would be her "own folks" for as long as she lived.*

The last words are those of the interviewer, Mary Hicks, who only briefly "knew" Betty. There are the bonds of memories and there are the bonds of family, but more important are the bonds of shared history. And memories belong here because they reflect the changing times. Thelma Koger Small, Betty's granddaughter, wrote in the Bethania AME Zion Church dedication book in 1975:

> *Her hands to me were fascinating. They were not fascinating in looks, not delicate or pretty—but oh, so skilled. She made shuck mats. She washed the wool from the sheep and carded it. She spun the thread and knitted the socks, shawls, sweaters, gloves and caps. She enjoyed weaving rugs by the yard on the man-sized loom. Her greatest pleasure was quilting beautiful quilts and making all kinds of garments. I even saw her make a pair of simple shoes. What could one admire more?*

Baustellen

Building Lots in Bethania of Olden Times

Timid women who have lamented to her [Wilson's wife] *that I purchased THAT House, telling many tales of ghosts, spirits, hobgoblins, apparitions, sights, and wonders and sanctioning an order to produce conviction with—I would not live there for the world.*
—Dr. George Wilson

Bethania's significance as a National Landmark town and Germanic linear village can be seen in detailed maps that show continuity of space and patterns of planned growth. Its core *baustellen*, or building lot plan, as designed by Christian Gottlieb Reuter in 1759, remains virtually intact. Outlying landscape, such as the Black Walnut Bottom, hills and crests, ridges and furrows, forests and meadows, creeks and streams and even some agricultural fields surrounding the town, are essentially present in modern-day aerial views. Although Bethania no longer exists today as a 2,500¾-acre town lot, a 500-acre National Register Historic District protects the historic properties.

In the early years, homes were simple log structures. Later, house fathers began to build two-story buildings for growing families, established trades in town and expanded farming endeavors. Additional building lots were carved from the orchard lots along the road to the Hollows. Bethania's rich Moravian and Germanic heritages are preserved in *The Records of the Moravians in North Carolina*, which offers historical evidence of the area's changing faces and spaces through time; however, these records are incomplete because they only represent the ministers' view of the town and its people. Non-Moravians, strangers, outsiders, African Americans and other individuals had a role in shaping the cultural identity of Bethania, and their voices are preserved in many other historical documents and memories.

Someone once told me that memory is not history. I disagree and feel that memory can help reconstruct a past that no longer exists, particularly when

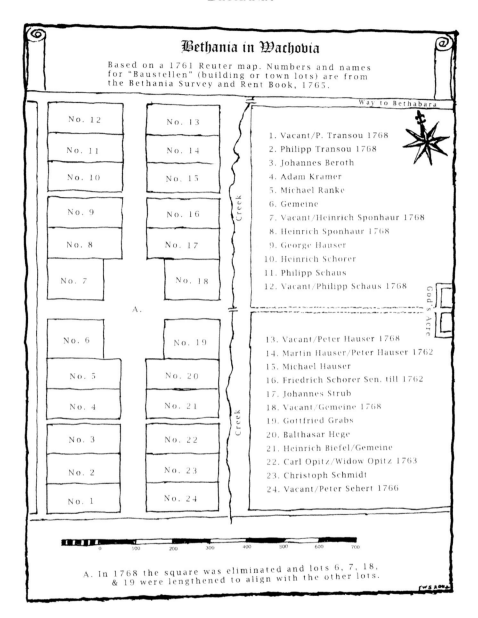

Bethania in Wachovia

Based on a 1761 Reuter map. Numbers and names for "Baustellen" (building or town lots) are from the Bethania Survey and Rent Book, 1765.

Way to Bethabara

No. 12 No. 13

No. 11 No. 14

No. 10 No. 15

No. 9 No. 16

No. 8 No. 17

No. 7 No. 18

A.

No. 6 No. 19

No. 5 No. 20

No. 4 No. 21

No. 3 No. 22

No. 2 No. 23

No. 1 No. 24

Creek

God's Acre

1. Vacant/P. Transou 1768
2. Philipp Transou 1768
3. Johannes Beroth
4. Adam Kramer
5. Michael Ranke
6. Gemeine
7. Vacant/Heinrich Sponhaur 1768
8. Heinrich Sponhaur 1768
9. George Hauser
10. Heinrich Schorer
11. Philipp Schaus
12. Vacant/Philipp Schaus 1768

13. Vacant/Peter Hauser 1768
14. Martin Hauser/Peter Hauser 1762
15. Michael Hauser
16. Friedrich Schorer Sen. till 1762
17. Johannes Strub
18. Vacant/Gemeine 1768
19. Gottfried Grabs
20. Balthasar Hege
21. Heinrich Biefel/Gemeine
22. Carl Opitz/Widow Opitz 1763
23. Christoph Schmidt
24. Vacant/Peter Sehert 1766

0 100 200 300 400 500 600 700

A. In 1768 the square was eliminated and lots 6, 7, 18, & 19 were lengthened to align with the other lots.

The Bethania plat and *baustellen* lots assigned to the first house fathers by the drawing of the lot. *Courtesy of the collection of the Moravian Archives, Winston-Salem, North Carolina.*

voices from the past speak to us through written words or oral histories. Emma Augusta Lehman documented her memories of the families who once lived in the houses of Bethania. She is a daughter of Bethania, born in 1841 to Eugene Christian Lehman and Amanda Sophia Butner. Emma was bright and had a keen interest in science, astronomy, mathematics and botany. She went to Salem Female Academy and finished within a few years because she had learned all that it could teach her. For a short while, at the age of sixteen, Emma opened a school in Bethania and later began a school in Pilot Mountain. She became engaged to a young man, Benjamin Chitty, but he died in 1863 in the Civil War, so Emma never married. Instead, she cut her dark, curly hair short and wore it that way for the rest of her life.

In 1864, Emma went to teach at Salem Female Academy and College, became head of the English Department and remained a professor there for fifty-two years. Scholarly botanists of the day addressed her, before they knew that she was a woman, as "Dear Mr. Lehman." Her discovery of a rare botanical plant of the family name *Monotropaceae* in 1903 at Roaring

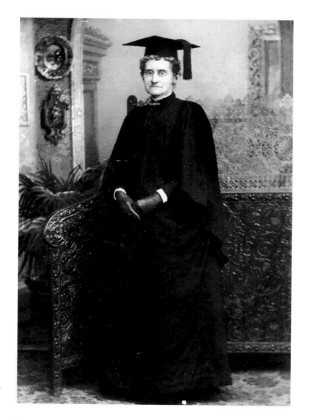

Salem College professor Emma Lehman, daughter of Bethania. *Private collection.*

Gap on top of the Blue Ridge, along with correspondence and personal records, document how the plant *Monotropsis lehmani* was later named in her honor, as was a building at Salem College, Lehman Hall. Her herbarium and other boxes of her memorabilia are stored on shelves at Salem's Gramley Library.

Emma wrote poetry, published a book, *Poems*, in 1904 and wrote the poem "The Silent Village" out of her deep love for Bethania. Her 1916 paper on Bethania, "Houses of Bethania in Olden Times," reveals a colorful picture of the people who lived within the village.

Another resident, Lola Butner, born in 1892, is also a daughter of Bethania and was in the first graduating class at Bethania's High School in 1912. She went to Salem College and taught for a while. Her memoirs bring to life another perspective and view of the changing times and street scenes in Bethania.

Other voices also speak from both the past and the present. While in reality, Bethania's *baustellen* may have changed over time, memories of these spaces weave through Bethania's history and tell its story.

BAUSTELLEN #24

Ghost shadows stand on this corner by the Old Stage Coach Road to Salem, now Bethania Road and Main Street. The present house looks like it has been there forever. Called the Eula Wolff House, it was moved from across the street, enlarged in 1931 and is still cared for by descendants. The Bethania survey and rent book for 1768 lists Peter Senert as the first leaseholder of the lot. The 1822 plat map lists Oehman. Later, according to Emma, a Hanke and Beckle operated a store there until 1835, and in 1836, H.H. Butner and his son-in-law, Eugene C. Lehman, Emma's father, had a mercantile store there. E.C. Lehman took sick on a trip to Baltimore in 1856 and died there on March 16. After the Civil War, F.A. Butner and O.J. Lehman, Emma's brother, took over. They brought in J.H. Kapp about 1871. The firm spread, and they built five more stores in the outlying towns. They also built a tobacco and plug factory on the opposite side of the street and a warehouse on the north side of the store. The businesses were prosperous, particularly the tobacco endeavors, until Kapp died in 1896 and O.J. Lehman sold out to the Bethania Stock Company. The store and storage building were demolished in the 1940s.

Lola Butner describes the store that once graced the corner of Main Street and Bethania Road:

The Village by the Black Walnut Bottom

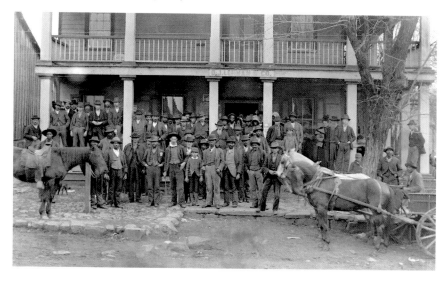

The Lehman Kapp Store, about the turn of the twentieth century, captures the essence of Bethania's tobacco heyday. The mill hands standing in front of the store, black and white alike, look stern and worn. *Photo by J.L. Kapp.*

The first car in Bethania. *Photo by J.L. Kapp, circa 1900.*

There stood a large picturesque old building with a downstairs and upstairs porch supported by large pillars on the west and south side. Southeast of the building on the road was a well with a large trough for water, where wagons stopped so the horses, mules or oxen could drink. The building also housed the post office in a room in the back. I remember Mr. O.J. Lehman as the first postmaster. The store was filled with all kinds of merchandise— groceries, candies, dry goods, dishes, tobacco, snuff, molasses, oil, food for livestock—just about everything one could think of. My brother Raymond bought a little glass sugar bowl for $.10 and gave it to mother for her birthday. About 40 years later at a sale, it was sold for $3.75.

BAUSTELLEN #23

Continuing north on Main Street's east side, the Bethania survey and rent book lists the first leaseholder of lot twenty-three as Christoph Schmidt, a captain in the Revolutionary War. The home here was later lived in by Peter Hauser. "When I was a little girl," Emma said, "I remember going to a poor, one-story log house, with only a door front and one window, rather dilapidated, and seeing old Uncle Peter Hauser, a venerable, gray-haired man, sitting in front of his humble dwelling." Bethania's committee notes that in 1841:

The request of the widowed Br. Petrus Hauser for release from his congregation contributions was brought up. Because of his circumstances the committee thought they could let him off although he would continue baking for the Lovefeasts.

Peter Hauser died in 1847 at the age of eighty-two. Emma recalled, "I remember the weeping of his daughter Mary afterward. Mary went to live with a brother, remarried and returned to Bethania as a widow in her old age. She was known to all as Aunt Mary and lived in a shoe shop." The old log house was torn down. Ed Butner built a new house, circa 1848, and lived there for a while. When he moved, the house had a series of renters. Lola Butner remembers a family named Strupe living on this lot—a farmer and his wife, Miss Minnie, who kept borders, "mostly teachers and pupils of Bethania High School." The present house is cared for by descendants of the first settlers.

This bake oven was reconstructed from a nineteenth-century glass slide. *Photo by Bowman Gray.*

Baustellen #22

This house looks deceiving from the road. The inside is mainly log construction and the rooms are endless. This is the second house that my husband and I restored. The original leaseholder was Carl Opitz; Michael Kirschner came next. The house was named the Abraham Transou House because his initials, "A.T." in ancient script, and the date 1776 are carved into the chinking in one of the front rooms. Transou rolled one of the first schoolhouses in Bethania onto the lot. This became the kitchen and was eventually connected to the house by a dogtrot, now an interior room.

After Abraham's death in 1833, Elias Schaub, his nephew, bought the house for forty-four dollars at auction. It was here, at Schaub's first house in Bethania, where the citizen's of Bethania were called to vote on an "Act to Incorporate the Town of Bethania" and an "Act to Incorporate a Fire Department in Bethania" in 1839.

Elias Schaub moved to a new lot up the street and established his gun and rifle, clock-making and jewelry shop. Thomas Schaub moved in next and established a wagon shop. He planted a row of tall Lombardy poplars on the south side, and he contrived a platform next to the building where he hauled the carriages and buggies up to the second floor. Emma and her cousins loved this room:

I used to go up there at night and view the stars as we studied astronomy. It was a capital place. One night we sat up there waiting until after midnight to see Jupiter rise, and he was fine too. (Around 9:00 p.m. and halfway up from the horizon, near the constellation Leo, Jupiter can be seen in the eastern night sky.)

Other residents of this house included Grabs, Leinbach, Ritchey and Ciccollela. During the 1920s, a switchboard was operated here, and you can still see the holes in the thick log walls where the phone wires at the top of the front door came into the house. Few people remember that Mr. Ciccolella was famous in his own right. He earned his doctorate at the age of nineteen and then joined the U.S. Coast Guard. He became one of the foremost experts in lighthouses, traveled all over the world and revolutionized how lighthouse beams flashed and reflected along the coastlines worldwide. Mrs. Ciccolella was a Sprinkle and her family roots go back to the early years of settlement in Wachovia.

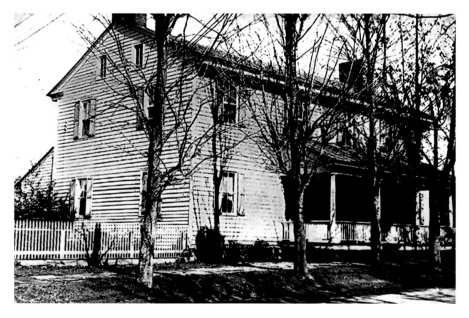

Many of Bethania's homes are lived in and cared for by descendants of early families. *Collection of the Old Salem Museum and Gardens.*

BAUSTELLEN #21

A lane no longer in use cuts through the next lot, which was first assigned to Heinrich Biefel. The house is named after Solomon Transou, who once had a wagon shop here. Emma remembered Solomon Transou as "a very smart man, original, gifted, and a peculiar man and having a number of slaves." His father, Abraham, lived in the house first and deeded the house to Solomon when he married. After having a family of seven children, Solomon bought a large plantation and moved his family to Lewisville, "but the wife got so homesick for Bethania, they came back after two of the sons died." The house also belonged to Emma's uncle, William Lehman, before the Civil War. Later, another uncle, Henry, had a tailor shop on the property.

Lola Butner remembers E.T. Lehman and his wife, Miss Emma, who was beloved by Bethania's children:

> *She was a well educated woman and graduated from Salem, never had children of her own and so the young people congregated there. She was like a mother to me. Many nights we young people would gather there, play games, sing and eat. She made drinks out of jelly and water when she didn't have anything else.*

BAUSTELLEN #20

This lot was first designated for Balthaser Hege. His granddaughter married Daniel Butner. "Uncle Daniel Butner," Emma recalled, "owned several slaves, old Lucy, Lawson and Henry, who was born there and raised like a white child." Later, her uncle Robert, Lola Butner's father, had the property, and Lola grew up in this house. Lola is a lot like Emma Lehman: she never married, she went to Salem and she taught for a while. Lola moved back to Bethania and lived in the house for some thirty years. She says that earlier families who lived in this house were Rights and Oehmans—all-important to the early years of Moravian history. The house has been meticulously restored by its owner, and the interior is like stepping back in time.

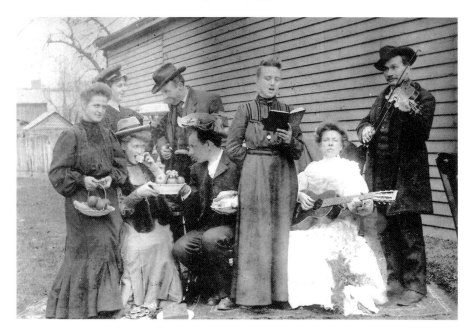

Bethania traveling minstrels and performers. *Private collection.*

BAUSTELLEN #19

Now called the Speas House, this lot held the first log house built in Bethania. This is where the Gottfried Grabs family came to live in 1759. In Emma's time, a gabled house with a porch facing the north stood on the lot, occupied by the Christian Grabs family during the mid-nineteenth century. Emma wrote:

> *Christian Grabs would blow a horn every day at quarter before twelve. Then the farmers in the fields would come home to dinner…Old Mr. Grabs owned some negroes: Jake, Louis, Manny, and Tildy. He had a still house too, on the side of the old graveyard walk. In the early days, it is said, there was one* [still] *on almost every lot. I remember only two. One on the Conrad lot and one on the old school house lot, before the late high building was erected.*

Lola remembers the house as being lived in by another Grabs and then the Speas family, "where the daughters lived during the week so that they could attend the high school here." The present house was erected about 1914.

The Bethania Moravian Church and parsonage, 1950. *Courtesy of the Forsyth County Public Library Photograph Collection.*

BAUSTELLEN #18

Designated as the *gemein* lot, the first building, completed in 1771, faced the street. It served as the pastor's residence and the second place of worship until the brick church was finished in 1809. This *gemeinhaus* then served as the parsonage until 1859, when a new one was erected. In later years, the second parsonage was used as a Masonic lodge meetinghouse, and in the 1960s it was moved to its present location on the lane toward God's Acre. The creek that runs behind the old lane once had a springhouse that bordered the property. The landscape leading to Bethania's God's Acre is secluded, and the graveyard is protected by fencing and an iron gate. The week before Easter, people come from all over to tend the graves. This is perhaps one of the most beautiful of times, and the Easter Sunrise Service is well attended,

The Bethania Church brass band. *Photo by J.L. Kapp, circa 1900.*

rain or shine. This ritual has taken place since God's Acre was consecrated in 1760.

Sadly, on the evening of November 3, 1942, disaster struck Bethania, and the church that had stood in the same spot since 1807 was devastated by fire. Ernest Miller wrote, "The destruction almost complete. All that was left was the stout brick wall of the church…People rushed to save what they could—the piano, pulpit chairs, hymnbooks, choir robes, coffee and communion services and supplies. So much had been lost, but at least no one was harmed." Because the new church resembles much of the old, the character remains intact, and the building was dedicated on October 20, 1946. The Christian education building was added in 1956 and expanded in early 2000.

BAUSTELLEN #17

The Bethania survey and rent book lists Johannes Strub (also spelled Strupe and Strup) as the leaseholder of lot seventeen. The 1822 plat also shows a

Strub, and by that time the lot had already expanded into lot sixteen. Emma noted that "the house above the church was a double-house" and remembered cousins and other relatives who lived there. Emma's grandmother Strub, who married H.H. Butner, was born in and lived in the first house built on the site. She died in 1852. The lot was sold to Herman Stoltz, who built a new house and operated a dairy farm on the lot. The house is still lived in and cared for by a descendant.

BAUSTELLEN #16

Lot sixteen is listed for Friedrich Schorer and son, and then Abraham Lash, on the 1822 plat map. Lash married Catherine Hauser, who was the widow of Jacob Schorer. Both Abraham and Catherine died in the 1840s. There was an early structure on the lot until this particular lot merged into lot seventeen. The Schorer name has changed and is sometimes spelled "Schor" in early records. It is now most often spelled "Shore."

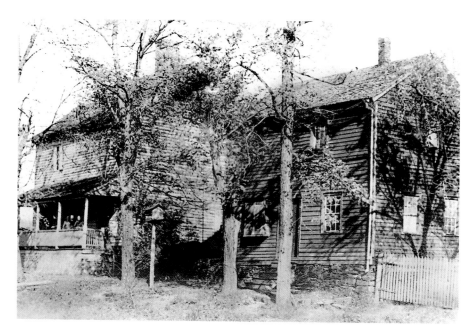

The Elias Schaub Shop and Home. *Collection of the Old Salem Museum and Gardens.*

BAUSTELLEN #15

Michael Hauser was the first leaseholder of lot fifteen. Other records indicate that Isaac Lash, son of Abraham Lash, came next, and then Elias Schaub opened his jewelry, clock and gun shop here. The house stood close to the street, and an old photograph shows a giant clock in the window. Schaub made handsome guns and rifles and magnificent clockworks that are prized collectibles today. Stoneman spent several hours with Schaub during his raid in Bethania on Easter 1865. Emma noted, "Elias Schaub is the only one who didn't have a horse stolen that week. Between the shop and house he had a flower garden and a long white Bee Palace where he got a lot of honey." The building was torn down, and the present owner preserved the former house's foundation when he erected the new dwelling. Emma ended her reminiscence with a sad note:

> *Mr. Schaub had a very tragic death. Coming as usual from his and Mr. Crater's Mill with his buggy and Bill, his horse, he was found dead by the roadside, I think it was about 1881. The horse was entangled in his harness in the bushes not far off.*

BAUSTELLEN #14

Martin Hauser is listed for lot fourteen, which was extended into lot thirteen at an early point in time. Most Hausers who settled in North Carolina trace their lineage to the first Martin Hauser, the family patriarch who died in Bethania in 1761. He had six sons, including twins Martin and Jacob. While many members of the family joined the Moravian Church, other progeny became affiliated with the Methodists, Baptists and Shakers. Martin Jr. was known to preach outside on the corner. It came as no surprise when he and his family moved from Bethania in the late eighteenth century because Martin wanted to join the Methodists.

This house is noted as the Cornwallis House and is where Lord Cornwallis encamped for a night during the Revolutionary War. The house is also called the Hauser-Reich-Butner House. Leon Butner and his wife lived in and began restoring the house in the first quarter of the twentieth century, at a time when many families were doing the same. Earlier, Nathan Reich, a painter, lived in the house, and the present owner uncovered a wall mural that has since been restored and once again can be enjoyed.

The interior of the Cornwallis House. *Courtesy of the Forsyth County Public Library Photograph Collection.*

BAUSTELLEN #13

Now an empty space, Peter Hauser is listed for lot thirteen in the 1768 rent book. Heinrich Hauser (Saddler) is listed on the 1822 plat, and he, too, died a strange death. Emma wrote, "He was talking across the street to Mr. Abram Conrad, when he fell dead of apoplexy."

ORCHARD LOTS

Continuing Up Main Street and the Old Hollow (Bethania–Tobaccoville) Road

If one should desire to extend Bethania for more families, there is the means to do that. One needs only to take a couple lots from the orchard land, and thus one can easily construct a whole new row of houses.
—*Spangenberg*

The lots on Main Street above Rural Hall Road and Loesch Lane are not part of the original *baustellen* plan and were split from the orchard lots beginning in the late 1760s. One map dated 1766 shows a large lot marked number five (Michael Ranke) where a spring is located and feeds into a small creek running behind the back lane of the east side of Main Street. Above this is a lot marked number six, belonging to the *gemein*, or church. Another plat shows an orchard lot marked number thirteen, facing Main Street; this would have been leased to Peter Hauser. Michael Hauser is recorded on the 1822 plat.

Michael Hauser House

The first house on the northeast corner of Bethania–Rural Hall Road is known as the Michael Hauser House. While other families lived in the house through the later centuries, Emma remembered her uncle Henry Lehman, who lived there before the Civil War:

Uncle Henry owned some negroes, too. Pricilla, who had two children (Adaline and Reuban), was sold to a trader for some wrongdoing. She was our Nathan's first wife, and it was hard to leave her two children here. I think, too, she had a baby that she took with her. Nathan later married Milly (a good-looking girl of seventeen), belonging to Dr. George Wilson.

The Village by the Black Walnut Bottom

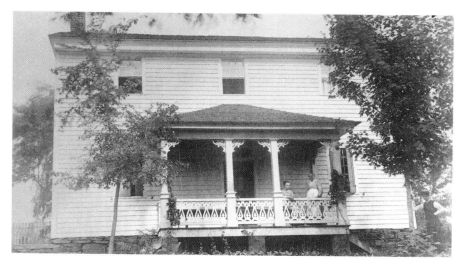

The Michael Hauser House. *Courtesy of Old Salem Museums and Gardens.*

I wrote the name of twenty-five of his children in his large Bible for him. He probably had more that he failed to remember.

Lola Butner remembered this house as the George Porter home, and then as belonging to the Hunters, who sold the place to Mr. and Mrs. James Drage, an English couple. I came to know David and Ruby Drage, who told me that they moved to Bethania in 1930s to live with David's parents. The little house next to the main house was built by David's sister, Evelyn, who lived in it until she died in 1978. David, Ruby and their son, David Jr., owned the land until both David and Ruby died.

David operated an electronics business before he retired, and Ruby was a woman of many talents and an artist. They were a beautiful, small and fragile couple, but spry. Ruby was Bethania's postmaster for many years; she also worked for Dr Strickland.

I remember the energy that exploded from inside the house. The interior had exposed log walls, a narrow stairway with a forty-five-degree angle and narrow upstairs bedrooms. Ruby had paintings and papers everywhere, and David still tinkered with old radios. They loved Bethania and told me stories of their early years in the town. Later, Ruby gave me handwritten reminiscence notes of her early days in Bethania:

Our land behind the house goes to the water station and north, where it joins Stoneman place farm, garden and orchards (before the present housing

119

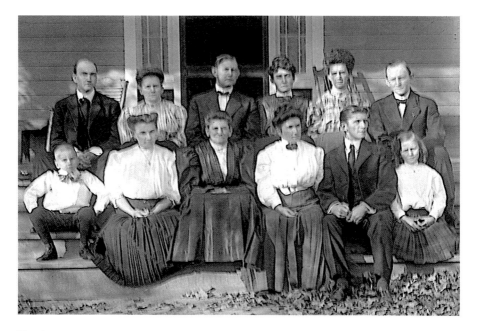

The Kapp and Ogburn family. *Photo by J.L. Kapp, circa 1900.*

development). I remember the old mill site still standing, just around the bend on the creek by Long Creek Club, beyond six acre court farm was the site where the mill and gun rifling works stood, some of the guns made in Bethania are in a museum in New Orleans. The streets were quiet then, children would play marbles and shoot them across the road. Young'uns didn't have cars at that time; it was a privilege to have a family car. You could sit on your front porch, and hear the wild geese, and sparrows sing in the trees.

Before David and Ruby died, the house had fallen into ruin. It is now being brought back to life. I see the workmen on my daily drive to the post office, watch the progress and know that the former caretaker/owners would be pleased with how the house is progressing.

Adam Butner House

Above the Michael Hauser house is the Adam Butner lot, though the original house is gone. Stoltz built a house here in 1886, but it was torn down in 1995. This lot is where Emma's grandfather, H.H. Butner, and his seven

brothers were born. Emma recalled that her great-grandfather and H.H.'s father, Adam Butner, married "the widow Frey, a little bit of an old, dried-up woman who was always carefully tended by her grandfather till she died, for he said she was good to her step-children." When the old people died, the house fell into decay. The building stood like this for many years until a Butner descendant built a new home on the site.

Fredrick Hauser House

Fredrick Hauser built a house on this site about 1780. Emma said that this was her grandmother Lehman's first husband. Her grandmother, though, never wanted to speak of this marriage, as they divorced at a time when divorces were rare and not accepted. Instead, Emma spoke of an aunt, Traudel (Gertrude) Stoltz, who lived in the house during a happier time:

She was everybody's aunt, and a widow. She was a character. Her maiden name was Leinbach and she lived there alone, always having a pet dog,

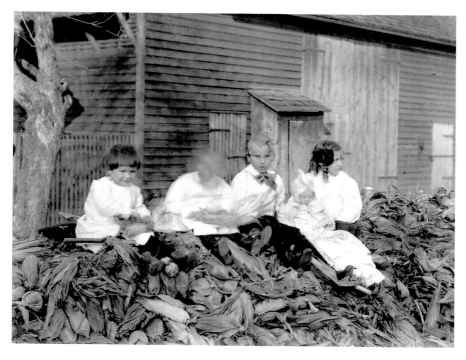

Corn husking, also called shucking, was an event in Bethania. *Photo by J.L. Kapp, circa 1900.*

121

manufacturing snuff, which then, was largely used by old ladies and gentlemen. She raised silkworms and sold sewing silk of beautiful colors. We children loved to go for snuff, for she always gave us something; great luscious pears, red juniper apples in their season but always something.

Stauber Farm

The Samuel B. Stauber Farm now consists of a nineteenth-century Greek Revival farmhouse that is on Bethania's National Register of Historic Places. Located two miles north of the village, the site is above the location where the Jacob Conrad Home burned to the ground. Emma remembered visiting a place called the Staubert-Ebert-Peddycord House, then occupied by Jacob Conrad, who died in 1848. While Emma said the buildings were brick, a Bethania diarist noted on April 16, 1851:

In the afternoon two houses, namely those belonging to Sr. Conrad or the Lemlys, caught fire. Most of their belongings, it is true, could be saved. However, the houses—of two stories—burned to the ground. One was a log house covered with weatherboards; the other, a large fine frame house that had been painted quite recently. How the fire started is unknown. It began in the old house, though no fire was lit any longer. It is thought that perhaps a cat caught fire at the bake oven and ran with a living ember into the old house and set it on fire. The belongings which had been saved were stored in the Ort [tavern]. The family, however, stayed at Dr. Jones...The Widowed Sr. Elisabeth Conrad, m.n. Loesch, and her children, the Henry Lemlys and family moved to Salem, 7 persons who belonged to the congregation. [In late August,] Br. Stauber has bought Mrs. Conrad's old plantation for $2000.

WEST SIDE OF THE ROAD BACK TO BETHANIA

Dr. Beverly Jones Plantation

The brick main house is grand and stately, with the front entrance facing away from the main street. The first view a passerby would see is the summer kitchen. A storm a few years ago felled a tree and destroyed the building—a magnificent place that could easily have been a separate home. The process of reconstructing historical buildings is a tedious task and can take years. The property contains original outbuildings, which were also damaged in the storm and are under restoration. The family cemetery

Dr. Strickland's buggy. *Photo by J.L. Kapp, circa 1900.*

is less than a half mile from the town. Although the plantation, Stauber Farm and gristmill site are in the Bethania National Historic District, they are outside the town limit.

Orchard Lots

Now fronting Bethania's main street above Loesch Lane, the early map shows the first lots as number four (Kramer) and number seven (Spoenhauer). When the lots were redesigned, the lot facing the road was assigned number twelve and extended into number seven. It was leased to Phillip Schaus. One of the more infamous Bethania land disputes tells of the apple rebellion. Phillip Schaus, who was one of the first non-Moravian settlers in the upper town, took his family and moved suddenly and quietly away. A story was told that Schaus had sold his apple trees to a Bethania resident, Wolff, who in turn sold them to another resident, Heinrich Schorer. However, Schaus came back a few days later and took the apples. This left ill feelings, as Schaus claimed that he had the right to sell the apples and that his lease read differently then Schorer's. Because the apples had grown while Schaus

had leased the land, he felt that he still owned them. Friedrich Marshall, the chief administrator, met with arbitrators to settle the dispute. It was agreed to pay Schaus eight pounds to satisfy his claim for improvements and deduct for the damage he had done to the lot. Casper Fisher took over the lot, followed by George Hauser.

Bethania Post Office

The present building was erected in 1970; however, Bethania had one of the first postal routes established in the United States. Since 1789, mail routes have been located on various sites, including the tavern, the inn and the Loesch and Lehman stores.

Below the post office stood a log cabin occupied by T.C. Johnson. Emma Lehman recalled that he was a squire and a shoemaker who "raised a pack of bad boys." Years later, Lola Butner wrote about this same cabin in the early 1900s. She said that it was

> *where Uncle Lewis Miller, a black man lived with his two sons, Ben and Sam. We children, especially on Sunday afternoons, would go up the narrow rocky path on the west side of the street and listen to tales about the past.*

Jacob Conrad had a store on the next lot, and in the early 1800s, Dr. Shuman lived here before he moved to Salem. Just below this house was a smaller house with barred windows where Lewis Lash lived in 1830. Dr. Wilson wrote, "[He] in a measure is insane, produces much trouble for us as he is frequently here when I am from home and uses abusive language—even his own people do not take care of him." Emma remembered the house and that Lewis "became crazy over study" and lived in the house by himself. The Bethania congregation diary in 1856 read, "Lewis Lash burned the broom Sage in town." He was taken to the asylum in Raleigh in May 1856.

Bethania Tavern Site

The last corner lot before Loesch Lane and Main Street is where the Bethania Tavern stood. Tavern keepers were Martin Hauser, George Hauser Sr. and, after his death, George Hauser Jr., followed by Christian Heinrich. Johann Grabs purchased the tavern in 1818. The tavern was still operated by Grabs in 1829, when Dr. George Wilson came to what he called "Hausertown [Bethania]":

The Village by the Black Walnut Bottom

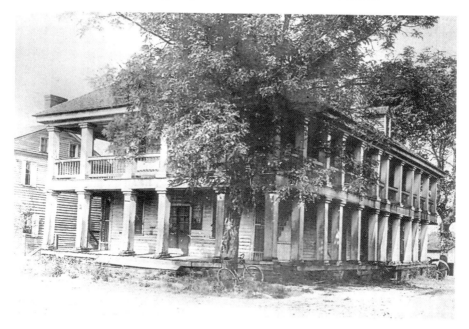

The Lash store stood on the corner of Main Street and Loesch Lane for more than one hundred years and was the western terminus of the longest and costliest plank road in the south. *Photo by J.L. Kapp, circa 1900.*

We arrived at our destination before sundown and put up in John Grab's Inn. He is a small, active man full of vivacity and attention. His wife is German but the handsomest featured woman I have yet to see in North Carolina and, if I were to guess, I think she is amiable, peaceable, unassuming person, calculated to be a wife and make a husband content.

Baustellen #12

Phillip Schaus is listed as the first leaseholder for both lots number eleven and twelve, which are on the opposite corner of the tavern. Johann Christian Loesch had the first grand store in Bethania on this site. Johann was an industrious young man, although Bethania was not Loesch's initial destination. He had been assigned by the Salem Church Board in 1779 to go to Bethabara and learn the operation of Bethabara's farm. The farm was overseen by the Negro Johann Samuel. This was an unusual arrangement and era for a young white man to learn a trade from a black teacher. Loesch returned to Salem and learned the operation of the Salem store under Bagge. After he married his first wife, Gertrude Hauser, he went back to

Bethabara to operate the tavern and store there. Bethabara, however, was not a profitable location, and he and Gertrude came to Bethania against the wishes of the church board in 1788, most likely convinced by George Hauser Jr. Marrying into the Hauser family was advantageous for Loesch.

George Hauser and Johann Conrad already had a store in Bethania. Peter Hauser had an extensive business with his guesthouse and farm and was encouraged to "build a new facility so that his family and his children are separated from outsiders." George Hauser erected a new store in 1789, and in 1803 the Aeltesten Conferenz decided that Bethania should have its own congregation store. The business was opened in 1804, was operated by Loesch and remained for the good of Bethania's congregation until 1822, when Loesch purchased the deeds.

There was also a tannery and a woolen mill on the back lane of the lot, and later, one of the first tobacco factories in North Carolina was operated on this site. The store was an "impressive two-story building with porches and tall pillars, up, down, and encircle[ing] the building," Emma Lehman wrote.

> *The cigar business was begun in 1841 and employed a number of colored hands, male and female. L.H. Livingston traveled all over the South with those cigars, and I.B. Chitty was the last to be connected with it. Adam Snow had the store until about 1863.*

The Bethania Moravian Church held Sunday school in the building after the store was disbanded. Lola Butner remembered the store as a rambling building that was a grocery store run by Howard Chadwick when she was in high school and then purchased by the Butner family. The building was torn down in the late 1920s.

Baustellen #11

This house is called the Johann Christian Loesch House. It was the first home my husband and I restored in Bethania. On the back of the property sits a smokehouse and carriage house that was built out of material from the old Loesch store. This is a wonderful house, and discovering its secrets as we began restoration was like going on a treasure hunt. Mrs. Nona Butner and her son, John Butner, shared many stories about the house's past and early life in Bethania. I discovered the complete works of the *Records of the Moravians in North Carolina* in a box under a shelf in a dusty antique store. In completing the Local Historic Landmark registration, I found that Johann Loesch's

memoir was never translated from German into English and commissioned the Moravian Archives in Salem to translate the paper. I learned that Loesch came from the same part of Pennsylvania where I was born—his family had lived in the same towns as mine, as did many of the other first settlers.

Loesch was a justice of the peace, and there were many weddings held in the house, which stayed in the family until the Butners purchased it in the 1920s. Mrs. Nona Butner made candles for the Lovefeasts for many years, and her candles were used in Lovefeasts as far away as Bethlehem, Pennsylvania. I have the drying boards she used and a pot. She made the candles in the 1830s summer kitchen, which has a walk-in fireplace with the original iron apparatus. We used this as our own kitchen during our first year in the house while our contactor was handcrafting the main kitchen and cabinetry work. We uncovered a fireplace and installed a commercial stove, handcrafted marble countertops and stone flooring. I remember holding my breath as we took Miss Nona on a tour of our work. She was pleased. We still had work to do, but then my company transferred me to a new state and new owners took over. Emma Lehman noted, "The old houses have their memories. It is no wonder the old cling to them." My company decided to

A view of the upper west side of Main Street. The buildings, from left to right, are the Rufus Transou House, Dr. Edward F. Strickland's office, the John Henry Hauser House and the Johann Christian Loesch House and store. *Collection of the Old Salem Museum and Gardens.*

downsize the week before we were scheduled to move. Fate intervened, and so we stayed in Bethania.

Baustellen #10

Heinrich Schorer is the first leaseholder for lot number ten, which was later expanded into lot eleven and is called the Johann Heinrich Hauser House. Later, Dr. Strickland and then Dr. Speas lived in the house. Abraham Conrad, who married Hauser's widow, lived there for a time. Emma Lehman remembered:

> *There was a large log house next below the present house, but Conrad's Negroes lived there. A Still-House stood right on the lane. Later, Conrad's Still-house as it was called was moved to the left-hand side of the road, about halfway between Bethania and the Dr. Jones place on the hill beyond the creek. Conrad's mill stood on the creek a little farther east. It was burned down by deserters about 1865 and nothing remains of it. Mr. Abraham Conrad lived with his daughter* [Julia Jones] *until his death.*

A house next to this house is where both doctors had their offices; it is cared for by a Conrad descendant. At one time, there was a lane between lots nine and ten.

Baustellen #9

George Hauser is listed in the rent book as the first leaseholder of lot nine. The lot was expanded into part of lot eight. The 1822 map shows a schoolhouse on the lot. Emma remembered the schoolhouse constructed by her father and others who believed that Bethania's town children should be educated by the minister. Later, the "Old Yellow House" was built in the nineteenth century by the church for a Mr. Kluge, who came to help Reverend Pfohl after he could no longer perform his duties. The present house is called the Rufus Transou House and was built by Transou in the 1880s. Several buildings on this and the nearby lot burned to the ground, and about 1800, a small building housed Bethania's fire engine.

Baustellen #8

This lot was originally held by Spoenhauer (Spainhour) and is now called the Ed Oehman House. Emma called it the old Joe Hauser lot. In her day, it was

occupied by Traudel Kearny and Betsy Hauser, both widows. The women made snuff in the 1840s and '50s. An earlier structure held the Wesley Kearney Shoe Shop. The present structure was built by Ed Oehman in 1930 and now serves as the Bethania Haus, owned by the Bethania Moravian Church. The house is used in many ways, one of which is to house families from all over the world during loved ones' stays in the area hospitals.

A Moravian diarist noted:

> *At 6 o'clock on the morning of January 7, the townspeople were roused to the sight of flames in the middle of the town next to the so-called school house. The flames were so great that those living in Bethabara saw the glow. A shed filled with flax and hay had burst into fire. The townspeople worked for hours to prevent the fire from spreading on to Joh. Heinrich Hauser's buildings. A still-house and shed collapsed from the heat, but the fire was contained.*

The diarist also said that there was a strong suspicion that the fire may have been started maliciously. The council met and put into place plans to make four cisterns in the center of town and to divert a creek in order to create a pond. It also agreed to purchase a fire engine and establish watchmen to guard the town each night.

Baustellen #7

Heinrich Spoenhauer is listed for this lot, now called the Jacob Loesch House. It is a prototype of the first log homes in Bethania. Later, this was where Gottfried Rineholt Oehman lived. Lola Butner remembered her aunt Louisa, who had a loom and wove carpets. She had an outdoor oven where she did her baking. Lola recalled "seeing her shove in sheets of Lovefeast cakes" that she baked for the church. The smells of bread baking had to have been marvelous. The oven was destroyed, but by a stroke of providence, an original glass negative of a photograph taken by J.L. Kapp of the oven when it was still in use was given to the owner, who had the oven reconstructed. The setting, along with all the outbuildings, is like stepping back into the colonial times, and one can envision how busy life was back then.

Pythian Hall and Schoolhouse

Jan Hus Lane is named after the martyr of Moravian beginnings. At the end of the lane is Pythian Hall, erected in 1897 on Seidel Lane, named for one

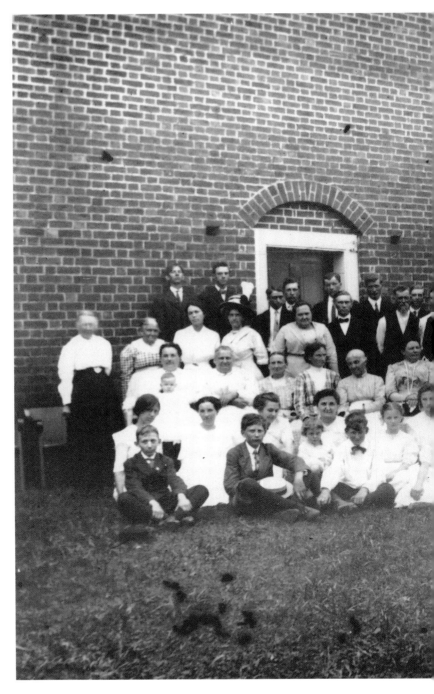

The Oehman family birthday celebration, 1910. *Courtesy of the Old Salem Museum and Gardens.*

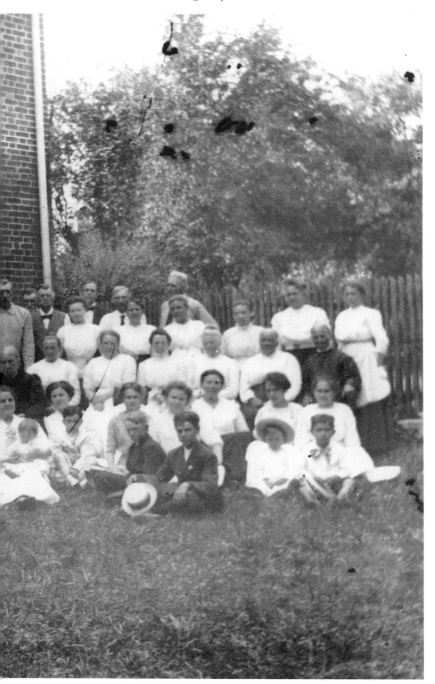

The building of Pythian Hall, later the first high school and home to the Bethania Historical Association. *Photo by J.L. Kapp, circa 1900.*

Bethania High School. *Courtesy of the Old Salem Museum and Gardens.*

of the first pioneers who came to Bethabara and died in the 1759 epidemic. The first structure was two stories, and in the early 1900s, the building was recycled and redesigned into a schoolhouse, where all grade levels were taught. The school closed in 1924. The building now serves as the home to the Bethania Historical Association.

Baustellen #6

This lot is where the original *gemeinhaus* stood, but it was washed away within a few years after it was built. After the new *gemeinhaus* was built on higher ground across the street, the church had a garden on the old site. Later, Lola Butner remembered this as a vacant lot where an attractive log cabin was built in 1920 by R.M. Butner. The Boy Scouts helped to build the structure. Even earlier, the Bethania Band had a bandstand there, where they practiced and gave band concerts.

Baustellen #5

Michael Ranke is recorded as the first leaseholder for lot number five. The lot was enlarged in 1771 and took over a part of the *gemein* lot. Although the building is now referred to as the William Stoltz House (Stoltz built the present structure in 1864), Dr. George Wilson's house once stood here, but it burned to the ground sometime before the Civil War. This is where he had his medical practice and drugstore. Emma wrote:

> *I well remember his* [Dr Wilson's] *regular horseback and saddle-bag practice. My latest recollection of him as a stout grey-haired man, who came to our house when my sister Sallie was born and ate supper on that Easter evening. Later the family moved to Yadkinville where Mrs Wilson's brother, Theolphilus Hauser lived. Dr. Wilson married Henrietta Hauser, half sister to Mrs. Beverly Jones (Kate's mother). Heinrich Hauser was her father…Their children were four boys; Henry a Doctor, Virgil a preacher, George who was hurt from a careless nurse, and Reuben who was well known during the Civil War. The girls were Louise, Mary, and Julia. I grew up with most of them and was much attached to them all. They owned many slaves who lived in a large house in the yard. Nathan our colored man when he was white headed, married Milly, a good looking colored girl of some seventeen years—the first wedding I ever witnessed as a child. Later when the family* [Wilson] *moved to Yadkinville, Nathan who owned a horse and buggy, used to go and see her, at first every two*

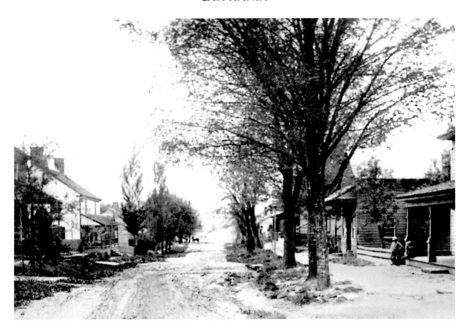

A Bethania Main Street scene facing south, circa 1900. On the left is the Daniel Butner House, the Solomon Transou House and the Abraham Transou House. On the right is the former site of the George Wilson House. The present structure was built in 1864 by William Stoltz. The small building was Stoltz's wagon shop and is now a brick, two-story building. The next house is Emma Lehman's family home. *Courtesy of the Old Salem Museum and Gardens.*

weeks, and later every four. When they were freed, he moved there altogether and could hardly make a living by working and stealing. He was finally put into jail because of it, and just out to die poor fellow. He was a good darky even if he tried to poison our family several times. He was a Hard-Shelled Baptist and believed after being immersed, you could do no wrong. Whatever you did was God's will, and therefore right. He could preach and pray and sing and steal and get drunk, and all was right. My father bought him off of Mr. Zimmerman and it was said that Nathan had helped him out of the world by strangling him—the marks were seen on his throat; I am able to say this much is true.

Dr. Wilson boarded young medical students who served as apprentices. His apothecary shop, where he made and furnished medicines, was located in two small rooms on the north side of the house, to the right of the passage from the front door entrance. Emma wrote, "To my childish eyes this was an enchanted realm." There was a fire in the early 1840s that destroyed several

The Village by the Black Walnut Bottom

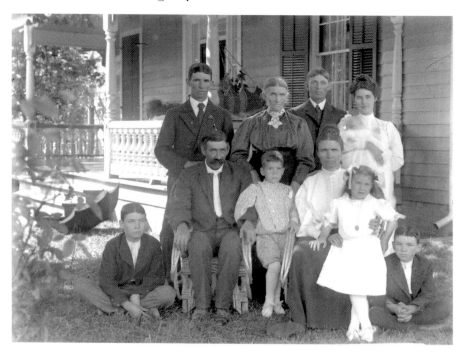

A Bethania family. *Photo by J.L. Kapp, circa 1900.*

old buildings. Lola Butner remembered the space next to the house at the end of the nineteenth century:

> *Between the house and shop Mrs Stoltz had a beautiful sunken garden. As a child I would go across the street, hand across the fence and wish for some of the flowers. Sometimes she would give me some. Below the shop was a big maple tree, and under it a well and a trough for water from the well near the road where men in wagons from up the country and mountains would stop to water their horses and oxen. The wagons would be loaded with different things, tobacco, grain, cabbage, chestnuts and other things. I would sit on the door step* [across the street] *and watch them unload.*

The wagon shop was moved to the back of the lot, and sometime in the 1940s, a two-story brick building was erected on the front of the property. There were apartments upstairs and a grocery shop and post office below. Then came an antique shop, a wicker factory, a cabinetmakers shop and my antique shop for the past twelve years. This building is the third property that my husband and I restored—or are still restoring, because old places

always need caring for. I have heard many stories about those who lived in the apartments, as newlyweds frequently took up residence in them so that they could be close to their families. In the olden days, a stove stood in the center of the building, and the people of Bethania gathered around the heat on a regular basis. I remember the first time I stepped inside the building and thought that I had entered a place that time forgot. The interior had a fusion of smells—from cleaning supplies to food cooking and the heady scent of pine logs. This building is the last remaining sign of industry on Bethania's Main Street.

Baustellen #4

Adam Kramer is listed as the first leaseholder for lot number four. Later, part of lot number five was added. This house is listed as the Shore-Lehman House, where O.J. Lehman lived until he was ninety-nine. The house was kept in the family until the 1950s, when it was sold to Mike and Dorothy Holder Carter, both early Bethania descendants. Emma Lehman described the house:

> *The front door was heavy and made of slate, or pieces, diagonally. You entered sort of a passage used for kitchens; only one chimney in the middle, a mass of brick, one long fire place in the kitchen, and another on the opposite side opening into the large sitting or living room…My grandfather's house as I remember, just before my sister's birth in 1849 had changes made…A shoe trade was carried on in a small frame shop that joined to the north and where my father, and presumably grandfather and his three boys, worked as*

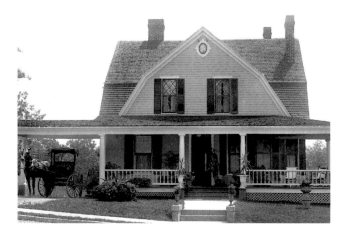

The Bethania home of Dr. Strickland. *Photo by J.L. Kapp, circa 1909.*

a shoe-maker. In those early days, everyone had to learn a trade, and it is still a notable German trait worthy of emulations…Later when Nathan was bought, he lived in this shop, for he too was a shoemaker.

Baustellen #3

Johannes Beroth was the first leaseholder of lot number three, later the homeplace of H.H. Butner; it was merged into part of lot two. The main house was torn down, and Dr. Strickland built a new house on the lot. Herman Butner was Emma's grandfather, and she recalled that there were many outbuildings, including Negro houses, a large gunsmith house and a blacksmith house. Herman Butner made rifles of renown that are coveted by collectors today. Emma contrasted a time between joy and sorrow:

Where delicious apple cider was made. My grandfather had a number of colored slaves too; Lucy with a large family, Jeanetette, Clementine, Malvina, Adeline, Jane, Edith, Angeline, Chloe, Irene, Robert, Erwin. Then too, old Archibald, Louis, Squire, a Mulatto. It was a great pleasure

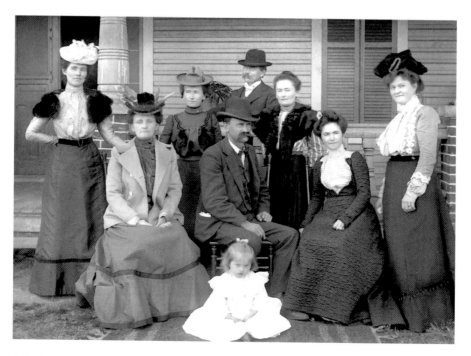

A Bethania family. *Photo by J.L. Kapp, circa 1900.*

to slip off and eat with them. Things tasted better than at white folks table. Grandfather Butner gave my mother a colored girl Adeline or "Dump." And to my Aunt Maria gave Jane, who returned all of our kindness to her by trying to poison [my Aunt]. Indeed she did kill her step-daughter, Anne Grunert, and her own baby, stillborn. So my Aunt never quite well again after those experiences, died July 13, 1869, with a stillborn baby. Her little son Jaimee, not quite two years died in 1870.

Baustellen #2

First leased to Phillip Transou, a house, wagon shop and early log home once stood on this lot. Part of the lot includes portions of lots one and two. The present structure is recognized as the Ray Butner House, built in the 1930s. Before this, Mrs. Eula Wolff's house was moved from this site and was relocated across the street to the old Lehman-Butner-Kapp store site on the corner.

Baustellen #1

Phillip Transou is also listed as the first leaseholder for lot one. Emma remembered a log house, which later became a loom or weaving house and then a wagon shop, where a boy named Billy Stoltz was an apprentice. A part of this lot was sectioned off, and a house was built about 1910, now called the Charles Griffith House. Griffith was a clerk in the Lehman-Butner-Kapp store and then operated a funeral home in Bethania.

Mat Butner Sides House

The last site on the west side of Main Street is not designated on the original survey, although it is listed on the 1822 plat map for Levine Grabs, who had a blacksmith shop near the creek. Lola Butner remembered "a beautiful old house and a long porch with steps and a flower garden where we children would make Easter rabbits nests."

Across the street is where Jack Speas, a colored man and his family lived. Lola Butner called him "a comical old man who on Saturdays peddled butter and eggs in Winston-Salem for years. Sometimes the creek would get up and water come up to the house. The old house was torn away years ago." In even earlier days, Daniel Butner ran a blacksmith shop here, used coal to forge the irons, labored from sunup to sundown and was assisted by a black man named Uncle Laws.

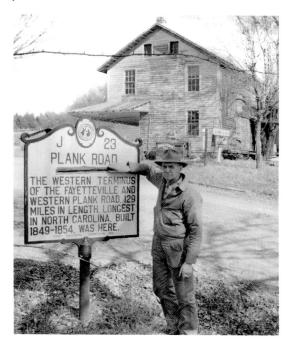

J.A. Shore with a piece of the plank road, 1959. *Courtesy of the Forsyth County Public Library Photograph Collection.*

Pecan Grove

Later named Kappi Domo, this estate was built in 1867 by John Henry Kapp. The house is classic Greek Revival and maintains much of its original features. Although the house is outside the town's limits, the Kapp family played an important role in Bethania's history and still live in the nearby vicinity. Reverend John Kapp was a minister of the Moravian Church for sixty years. His aunt, Emma Lehman, was a well-respected professor at Salem College for over fifty years. His mother also taught at Salem for several years prior to her marriage to J.T. Kapp, John's father. Louise Bowles Kapp is a woman of significance in her own right and taught in the Winston-Salem/Forsyth County school system for over forty years. Reverend Kapp and Mrs. Kapp helped to found the Bethania Historical Association in the early 1950s. Louise Bowles Kapp is the author of *Bethania: The First Industrial Town of Wachovia* and other books on the Moravian Church and Sunday school history.

Visitor's Center Complex

This corner space is now the home to new additions for Bethania—a town hall, the former Alpha Chapel, the Visitor's Center and the Wolff-Moser House.

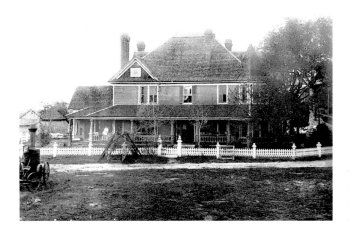

The Kapp family home, called Pecan Grove. *Photo by J.L. Kapp, circa 1900.*

The buildings were bound through history and memory to the community; they were in severe decay, so they were brought to Bethania, where they were restored. The Alpha Chapel, once a spiritual center and branch established by the Bethania Moravian Church, now serves as the town's meeting hall and business office. The late eighteenth-century Wolff-Moser House has been restored to its colonial grandeur. Community volunteers tend to the landscape and keep the area well groomed. At Christmas, there is a tree-lighting ceremony. Candles glow along the walkway from the church. In addition, Moravian stars hang from all of the homes' front porches. The scene is straight from a Norman Rockwell painting. Candle teas at the church during the season and Christmas Eve Lovefeast services are centuries-old traditions. It is not unusual for people to arrive one hour before the scheduled service because even "standing room only" is not available.

There is always an event planned in celebration of Bethania's annual anniversary commemorating June 12, and other events have been added that may become traditions in celebrating Bethania's heritage, such as a July Fourth celebration and, in the fall, the Black Walnut Bottom Festival. Visitors can walk through a landscape that time forgot, deep into the Black Walnut Bottom. Birds sing from their perches high in the trees, small animals rustle in the forested ground cover and color spurts everywhere. The Muddy Creek is true to its name, though at places along the path, the creek appears more like a river. The Black Walnut Bottom does not have fig or date trees, but true to the root of Bethania's name—Bethany, a place where "Jesus came to pray"—it is an escape of unquestionable beauty and quiet solitude.

CHAPTER 8

Other Spaces through Time

Bethania may well be the only Germanic-type agricultural community in North America built on the German Model, which can be studied today in such detail. The records are essentially continuous down through more than ten generations to the present.
—*Dr. Daniel Thorpe, historian/scholar*

At a time when a tree, a rock or another element of nature marked boundaries and occasionally served as fences, old building sites could easily be found. But, the old roadways and footpaths that crisscrossed the village and spread throughout its 2,500¾ acres are gone. Even so, Bethania's outlying spaces speak from earlier centuries and preserve their place in time.

LEHMAN-KAPP TOBACCO AND PLUG FACTORY

The Lehman-Kapp Tobacco and Plug Factory once stood on the site now occupied by Bethania's Visitor's Center complex. Tobacco was an important agricultural crop and was farmed in Bethania from the beginning of the settlement. The business could have survived had it not been for the death of an owner and the redistribution of property rights. After Kapp's death, the upstairs was used as a temporary schoolroom. The building was then sold to a Mr. Boger, who built a dwelling house from most of the material. At one time, there were apartments upstairs. Years later, Mr. J.A. Shore had a store that carried many items. His store was a popular hangout.

Young people favored the soda cooler at the side of the building on hot summer days and would then sneak off for a swim in the creek. John Butner tells a story of one young man who was anxious to jump in the water. The young man didn't look and wound up with his head stuck in mud. The

NOTICE!

I will sell at Public Auction on

SATURDAY, APRIL 15TH, 1893,

at noon, in Bethania, N. C., 3 miles from Bethania Station on the Winston & Wilkesboro R. R., one 60 Horse Steel Boiler and fixtures made by Pool & Hunt. One 45 Horse Corliss Engine made by Wm. A. Harris.

This Machinery has only been run 3 years. If you want a Boiler and Engine don't miss this sale. For further particulars address me at Rural Hall, N. C.

J. F. MILLER, Agent.

April 1st, 1893.

Left: An 1893 auction notice for equipment, believed to be from the old Lash store. *Private collection.*

Below: The old Shore store. *Courtesy of the Forsyth County Public Library Photograph Collection.*

others ran, thinking he was dead, but they were able to get him out in time. There are also tales from "older girls" who used the empty bottles and, along with the boys, played spin the bottle. And even earlier, back in the post–Civil War years, young people were seen dancing together. The church officials were flabbergasted and rose to action to see that this practice was stopped. Of course, as in the past, this fell on deaf ears.

G.H. Flynt

Just a ways down Bethania Road stood a gas station run by G.H. Flynt, a member of another old family whose name appears throughout Bethania's history. William Flynt served as one of the first sheriffs in Forsyth County, appointed in 1848.

Lehman-Butner Roller Mill

A roller mill built in 1899 stood on the east side of the Lehman-Kapp store. Most people remember this as the Manning Mill, and the mill was

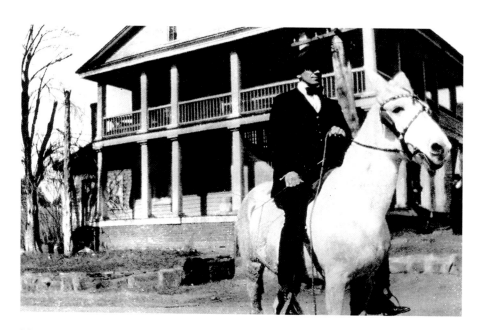

Main Street by the Stage Coach Road. *Photo by J.L. Kapp, circa 1900.*

in continuous operation until its sale in 2006. Now called the Bethania Mill and Village Shoppes, the building has been beautifully restored, given new life and turned into shops and an art gallery.

CHARLIE'S GARAGE

Across the street from the Visitor's Center complex is Charlie's Garage, built by his father, A.D. Wolff, who operated it as the Bethania Motor Company. The garage has been a fixture since the first days of automobiles and has been a family-owned operation for three generations.

HAUSER MILL

The old Hauser mill was less than one mile south from the town. There were two John Henry Hausers, and both were millers. One was called Saddler, meaning the elder, and was born in 1770. His cousin was born in 1784 and was referred to as Junior. Saddler operated one of the more notorious mills in town. A Bethania diarist, on July 21, 1824, noted:

> *Dr. Schuman says that he has never known so bad a fever in Bethania. Many people are convinced that the sickness comes from the mill-dam built many years ago one mile below the town. Much wood has fallen into the water and they think the vapors from it have caused the sickness, be that it may, it has been a trial for our poor town, and we are led to call upon the Lord for help.*

Mills required the damming of a stream in order to obtain the needed head of water. A millpond was needed if the water flow was not sufficient. Water was kept in the millpond overnight and then was used in the day to operate the mill. The damming of the water flow created many problems. The house fathers met often during the year to discuss what should be done, in particular, with Henry Hauser's millpond. A letter dated September 5, 1824, read: "It is the almost unanimous belief of the residents and neighbors that the millpond belonging to you and Mr Capp [Kapp], south of the town, through its noxious vapors, is a chief cause of the epidemic from here." The house fathers proceeded to Germantown on October 26 and filed a lawsuit against Hauser. The diarist called him on this occasion Johann Heinrich Hauser. A "True Bill" was found against the owners of the

mill, now including Kapp. The lawsuit lasted until 1829, when "the suit was taken out of the docket" and the mill partners were fined one dollar. Henry Hauser's wife, Amy, died on December 9, 1830, and Henry (Saddler) died in 1832. His memoir speaks of the "distress the mill-pond gave him."

BETHANIA GRISTMILL

Less than one mile north from Loesch Lane are the ruins of one of Bethania's first gristmills, located on what is now the Long Creek Golf Club on the Bethania–Tobaccoville Road. The first mill partners included Peter and George Hauser, Heinrich Shorer and Michael Ranke. The 1784 mill complex includes mill ruins, the dam, the millrace, the millpond bottom and two outbuilding ruins. Peter Hauser operated an inn, tavern and store near the site. The tavern had to be operated by a married couple because the church deemed that it was not "proper for single men to live at the mill where unmarried men and women were lodged overnight." There are visible cellar holes, timbers and stone. This mill was originally operated for the benefit of the Bethania congregation. At the same time that the other businesses operated by the church were dispensed of and sold, so was the mill. (Johann) Heinrich Hauser Jr., who took over the mill operation, died in 1821. Abraham Conrad gave a bond for the mill site because his new wife, Phillipina Loesch Hauser, wanted the land for her first husband's children. A copy of this bond is located in the Jones family records. Conrad is listed on the 1822 plat map, although Hauser's remaining estate had not yet been settled in 1830. Wilson wrote in 1830 "that by some mismanagement, Hauser became reduced in circumstances, and his estate of affairs was in an embarrassed situation upon his death."

By 1860, Abraham Conrad's health had declined. Dr. Beverly Jones took over the operation of the mill and kept ledgers of the mill's operation. Julia Jones oversaw the women's wash day, when unusually large loads were processed at the mill. Julia hired Betsy Stauber, a widow, to oversee the actual wash days. Betsy was an exceptional seamstress and made many of the fine hats that women wore during the antebellum era in Bethania. After the end of the Civil War, Bethania's countryside and outlying lots never recovered. Plantation life ended, land was sold and, by 1886, Dr. Beverly Jones held twelve hundred acres, half of Bethania's original town lot land.

The Conrad Mill was the site of a murder on March 29, 1858. The body of a Negro named Eli, belonging to Thomas Lash, was found in Abraham Conrad's millpond next to the Jones plantation. Lucy (Lucinda) Hine (also

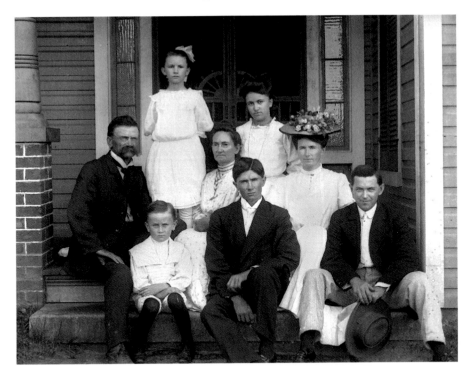

A Bethania family. *Photo by J.L. Kapp, circa 1900.*

spelled Hain and Hein), Eli's wife and a free woman of color, along with Frank, a slave belonging to Israel Lash, were both arrested and jailed the same day. Frank was a teamster and drove the wagons for L.H. Livingston, who was the agent for the Lash Bros. Tobacco Factory. Lucy's name appears in Bethania's diaries, going back to 1846:

The Negress Milly, a former member of the Methodist requested reception into the Negro congregation at Bethania and after the English sermon was the baptism of a free mulatto by the name of Lucy Hain. Blood was discovered on the floor of Lucy's cabin. Blood was discovered on the bottom of Lucy and Frank's shoes. Lucy claimed that Frank came to her house that night where Frank did the deed and removed the body to the millpond. Lucy's role was simply to clean up, which she didn't do very well. Frank was taken to the jail in Winston and Lucy transferred to Rockingham County. Frank was to have been executed in November but the Governor gave him a respite for three weeks, so that the multitude were disappointed, and this manifested itself in a strong feeling.

Frank was hanged for murder on December 17, 1858, and Lucy was hanged in January 1859. Israel George Lash was ordered by the court to pay for Frank's prosecution, but Lucy was to "pay for her own." Lucy was buried in Rockingham County.

KAPP MILL

The Kapp family has operated mills in this area since Wachovia was settled, including both saw- and gristmills, as well as the roller mill in Bethania. One Kapp mill, a sawmill, in the vicinity of Bethania is said to be outside the town lot near the northwest border. Another Kapp operated a mill before 1804, a half mile from town, when the diary notes that a Werner took the place of Heinrich Kapp at the mill.

ABRAHAM LOESCH MILL

Abraham Loesch, in addition to other enterprises, operated a mill located on the Muddy Creek in the early 1800s. A mill site is identified on Reuter's

Amanda Kapp. *Photo by J.L. Kapp, circa 1900.*

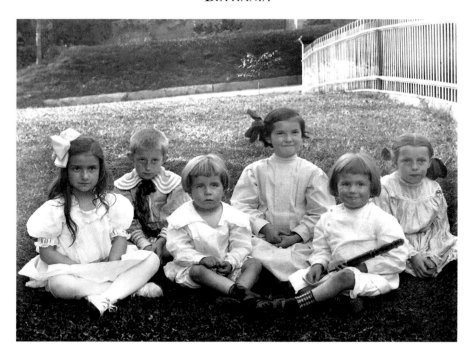

Bethania children on a summer day. *Photo by J.L. Kapp, circa 1900.*

1759 map near Loesch Lane with a symbol that represents a sun, or simple circle, with radiating lines. The site sits near a road leading to Old Richmond Courthouse, so it was well traveled, and crossed over a bridge on the Muddy Creek to the west. Today, the road no longer exists; it fades into the Lake Hills subdivision, picks up somewhere and then disappears again. At this same time, Johann Christian Loesch, Abraham's brother, had many business interests in Bethania. Before 1800, Loesch built a tannery and a woolen mill on the back lane, and slave quarters lined present-day Loesch Lane. Emma Lehman wrote:

> *On the right of the lane going west, where a large willow tree stood, a large farm, many negroes, much cattle, a saw mill, and a grist mill said to have been bought of Abraham Lash by Johann Christian Lash for his two youngest boys, I.G. and T.B Lash. There was an old dwelling house at the mill, inhabited in my early days by T.B. Lash's miller. It is probable Abraham Lash lived in the house when he operated the mill.*

The Village by the Black Walnut Bottom

Loesch Lane

The original orchard lots that stood along today's Loesch Lane now hold later-century homes, and some are lived in by descendants of the first settlers. Loesch Lane was an access point, and nearby bottom- and upland fields are still in agricultural use as they were originally planned. During the late 1700s and early 1800s, slave quarters were located on this roadway. Some historians note that this route was once known as the Old Richmond Road, even though there is another roadway leading from Bethabara and running along Bethania's southwest town lot. Loesch's Inn was located near original orchard lot number eleven, behind the tavern site. On February 20, 1849, Pastor Hagen wrote:

> *I became aware from a distance of a fire…a number of negro houses behind Loesch's Inn were ablaze and the people hard at work trying to check the flames. There was great danger of the fire spreading, for a number of large barns and other buildings were nearby, and in all likelihood they and thereafter the whole village would have become prey to the flames, if the Lord had not held his protecting arms. It was He who saved us for He caused the wind to grow calm and laid a light covering of snow on the roofs so that the sparks falling on them were put out. Meantime the beams of the burning houses were torn and scattered about and drenched.*

Remnants of old dwelling places are still visible beyond the abandoned roadway. This area was a former African American enclave site and contains remnants of separate dwelling houses. One such house is said to have belonged to a "root doctor," a spiritual healer who used certain species of plants to prepare his medicine. His land had patches of plants, some that caught the eye of botanists. The lot sits on private property in this century, and while plants still grow there, their secrets are no longer known. Betty though, remembered:

> *No'm, I don't know much about spells an' charms. Course most of the old folks believed in 'em. One colored man use to make charms, little bags filled with queer things. He called 'em "jacks" an' sold 'em to the colored folks an' some white folks too.*

CHAPTER 9
God's Acres

The marble doors of the houses are shut
The villagers lie asleep;
You wander in vain from place to hut
Their secret they sacredly keep

"Would I were at rest in this village still,"
A mourner wept alone;
"Would I were with them in the quiet hill,
Beneath this mossy head-stone."

—*from "The Silent Village" by Emma Lehman*

Moravians call their graveyards God's Acre, which stems from the belief that the dead are "sown as seeds" in preparation for Christ's return. God's Acre is not really an acre of land; rather, it is a metaphor for "resting place." Easter Sunrise Services celebrating death, "home going," and Christ's resurrection are a long-standing tradition. They begin on the front lawn of the church and culminate at God's Acre.

Bethania's God's Acre is beautifully maintained throughout the year; however, the Saturday before Easter is a part of tradition and ritual. The grave sites are cleaned and swept, and fallen debris is raked and hauled away. Plants and flowers are collected and then distributed throughout the fields of granite. Beginning at dusk on Easter Eve, a watch is held, and sentries stand by the gated entrances. Those of us who live nearby prepare for the rituals of "Night Watch" and "Solemnity." Beginning in early morning, the church band plays music outside our windows, moving up, down and around the town, calling all to wake. This is a magical experience and connects music

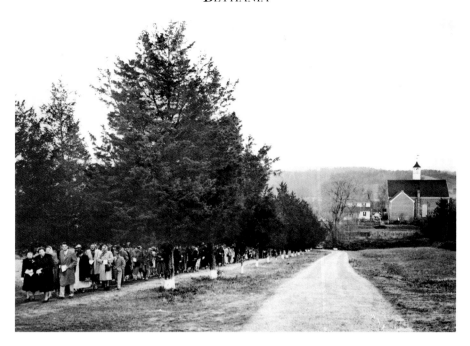

Easter Service, 1950. Bethania's Moravian path to God's Acre. *Courtesy of the Forsyth County Public Library Photograph Collection.*

and memories. In the dead of night, all of the empty spaces above us allow the music to resonate across the globe.

STRANGERS' GRAVEYARD

Slowly over the late eighteenth century, the practice of allowing strangers, or non-Moravians, to be buried in God's Acre eroded. In 1798, the congregation "renewed its agreement not to allow burials of outsiders in their God's Acre, unless in exceptional cases. This is more proper as they now have a burial place near their mill." The transcriber also noted that a graveyard "near the Bethania Mill was used for a time by non-Moravians of that section." Before the end of the eighteenth century, other sites were referred to as "our Parish Graveyard by the Mill, our God's Acre for Negroes, or our God's Acre for Strangers at the Mill." Because of the wording, it might seem that there was more than one strangers' graveyards—one for slaves and one for whites.

In 1803, a funeral was held for Jacob Miller "in the graveyard near the Mill." Jacob Schor was buried there, too, and so was William Carney, Anna

The Village by the Black Walnut Bottom

Margaretha Wright, widow Schumacher, Johannes Schaub, William Morry (a stranger from Virginia), Samuel Meyer, the stillborn son of the Styers and the Widow Gideon. A Bethania diarist notes in April 1814:

> *In the afternoon, in our Parish graveyard near the mill, Br. Pfohl held the funeral of the single man, Heinrich Seiler, who was found at our creek with his face in the water, dead. The Sermon had to be preached in the woods, for there was not place in the mill-house for the crowd that attended.*

Bethania's ministers also participated in burials held in family graveyards, such as those of the Pfaff, Schemel, Doub, Flynt, Spoenhauer, Wolff and Jones families. Additionally, an early 1800s diarist references one particular site long before the first official Negro graveyard was consecrated in 1847, "near the parish graveyard near Bethania, on the present road to Rural Hall Road—where in the cleared space near the mill, under an open sky; then the remains were given to the earth in a burial ground." As other churches were formed in the neighboring area, both this and other grave sites were lost from memory.

The Bethania AME Zion Church graveyard. *Photo by Bowman Gray.*

FIRST NEGRO GRAVEYARD

The Bethania AME Zion Church nestles atop a gently sloping hillside on a wayside along the Bethania–Rural Road between Walker Road and Bethania's Main Street. The church's God's Acre was consecrated on January 7, 1847, with the death of Millie (Lash). Here, the hillside turns downward, where the graveyard spreads beneath a treeless sky.

But what of the hundreds of other slaves who perished before this graveyard was consecrated, such as George Hauser's Negress Rahel, who was buried in September 1782? A Moravian diarist noted:

> *The negress, Rahel, passed out of Time, trusting in Jesus, and on the 28th was buried on the north side of the hill by Spoenhauer's field. She was born in Virginia, and was bought by Br. Peter Hauser when she was fifteen or sixteen years old. She had been here for four years and some months, being now nineteen or twenty.*

In March 1804, a funeral was held for "a Negro child belonging to Br. Grabs. It was interred at the Negro graveyard about ½ mile from the village." Shortly thereafter, according to the diarist,

> *the burial of the Negro boy Bob who belonged to George Hauser took place in Bethania's God's Acre for Negroes. The service was performed by the Negro Lewis who belonged to a Mr. Jean who lived a few miles from the town. They call Lewis their preacher, because he sometimes goes out and preaches to their race; he belongs to the Methodists. At the close of the service Br. Pfohl spoke to the Negroes in German which most understood. The Negroes sang several hymns at the grave of the departed, and continued to sing as they returned to the town.*

Another diary entry offers:

> *The free Negro Christian came from Salem and asked if I would preach the sermon for his brother, John Samuel who died on John Stoltz's farm [two miles from Bethania]. The remains were buried on Br. Christian Loesch's farm. I then rode to Stoltz's house (where the wife and two children live) and preached to a company of Negroes and a few white people.*

Between 1782 and 1865, there are many entries in the Bethania diaries for burials of Negroes and strangers. Unfortunately, this is only a partial truth because many of the diaries were recorded in the old German script, and not

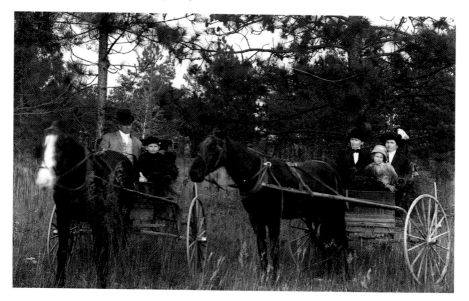

God's Acre. *Photo by J.L. Kapp, circa 1900.*

all of Bethania's records have been translated. Old age, seasonal epidemics, disease and wars, which ended on American soil, changed patterns for burials. One of the last entries records, in 1865, the burial of "the infant Miranda Stoltz, daughter of a free woman of color at the Negro burial ground between Samuel Stauber's plantation and Kapp's." Early maps may provide clues, and although the Moravian diaries are not absolute, locations of the graveyards can only be narrowed by reference to a name or a distance traveled; for example, many entries list "½ mile from the town." Spoenhauer's field would have been in this vicinity. On a new Forsyth County map, a graveyard is located between another historic Kapp homesite and the Stauber Farm, near the Jones plantation, a half mile from town.

Moravians believed that one's final resting place should be in a location reserved for peace. Somewhere in Bethania, on gently sloping hills beneath a Carolina blue sky, these strangers' graveyards have disappeared. What better place to rest than atop a hill, a crest or a ridge, near trees that bloom in spring or carry the scent of fruit in late summer or fall. There may be stones or other markers, or nothing but dirt and clay soil. The dead, buried like roots, sown as seeds, wait for the coming of eternity—ghost shadows flickering in the darkened night, storms howling in the wind, silent breezes gently ruffling through the trees. Bethania's memories are steeped in history and preserved in time. May the spirit of its people live through the eternities yet to come.

Night Sounds

Here, in the valley, two and one half centuries of night rhythms, journey
through seas of grey smoke the same color as sky
through weathered houses
through crevices of time

when night turns on the axis of its starlit eyes,
when the moon rises above Pilot Mountain,
when rain drops caress a tin roof top,

Shadow voices,
laugh and weep
between coarse, horse hair chinking,
whisper
between log walls thick as elephant legs.

Love glides through these old homes,
shudders and moans,
spreading like wine stains
across silver backed glass.

Floor boards creak
bodiless footsteps,
faceless hunters stalking their prey of heartbeats,
awakening flame-tipped heat,
from heavy sleep.

We lay breathing in love's down coverlet,
your hands furrow my body
smoothing the swollen tangles
folding us into a sea of night sounds.

Bibliography

MANUSCRIPTS, DOCUMENTS AND GOVERNMENT RECORDS

Acts to Incorporate the Town of Bethania and a Fire Department. State Archives, Raleigh, North Carolina.

Bethania AME Zion Church, 16th Anniversary. 1976.

Bethania Fire Department. Unpublished papers. Moravian Archives, Winston-Salem, North Carolina.

Butner, Lola. "History of the Class of 1911." N.d.

———. "Memoirs of Lola Butner (b. 1892, d. 1891)." N.d.

Defendant's Appellant's Brief. January 1997. Forsyth County 96 CVS 3104, Issue Brief No. COA96-1083. North Carolina Court of Appeals.

Drage, Ruby. "Personal Memoirs." 1996.

Forsyth, Rowan, Stokes [and] Surry County Records. Deeds, land grants, wills and miscellaneous records.

Hartley, Michael O. "Bethania in Wachovia, A Preservation Plan." Bethania Historical Association, Winston-Salem, North Carolina, 1989.

Hartley, Michael O., and Martha B. Boxley. "Wachovia in Forsyth." Old Salem, Inc., Winston-Salem, North Carolina, 1987.

Hartley, Michael O., Martha B. Boxley and Gwynne S. Taylor. "1990 Bethania National Register of Historic Places Boundary Increase." Document on file, United States Department of the Interior.

Hauser, George. Memoir, 1818. Moravian Archives, Winston-Salem, North Carolina.

Hooser, Randy. "Burned into Memory." 1997.

Idol, Bruce S., and Stephen T. Trage. "Excavations at the Dobb's Parish Cemetery and Bethabara Stranger's Graveyard, Forsyth County, North Carolina." Report. Historic Bethabara Park, Winston-Salem, North Carolina, 1995.

Jones, Dr. Beverly. Folders 1–61, Jones Family Papers #2884. Southern Historical Collection, Wilson Library, University of North Carolina at Chapel Hill, 1801–1932.

Joy, Deborah. "Archaeological Monitoring on Loesch Lane in the Bethania National Register Historic District, Forsyth County, North Carolina." Report. North Carolina Department of Transportation Division of Highways Planning and Environmental Branch, 1993.

Lash, Jacob Lofton. "History of the AME Zion Church." N.d.

Lehman, Emma. "Houses in Bethania of the Olden Times," 1916.

Little-Stokes, Ruth. "Bethania National Register of Historic Places Nomination Form." Report. North Carolina Division of Archives and History, Raleigh, North Carolina, 1975.

Loesch, Johann Christian. Memoir. Moravian Archives translation for the author, 1996.

Moravian Archives, Winston-Salem, North Carolina.

Museum of Early Southern Decorative Arts Research Center, Winston-Salem, North Carolina.

North Carolina Department of Transportation. "Bethania Traffic Study Report." North Carolina Department of Transportation and the City County Planning Board of Winston-Salem/Forsyth County, 1990.

North Carolina Historical Review. Raleigh, NC: State Department of Archives, January 1953.

North Carolina State Archives, Raleigh, North Carolina.

Oral histories of Bethania residents by the author, 2002–2006.

Salem College, Gramley Library, Winston-Salem, North Carolina.

Sensbach, Jon F. "African-Americans in Salem." Old Salem, Inc., Winston-Salem, North Carolina, n.d.

Slave Owners, Rowan, Surry, Stokes [and] Forsyth County, 1780–1863. N.d.

Snavely, Alan N. "Dobb's Parish Graveyard/Bethabara Mill Dam: Archaeological Investigations at Historic Bethabara, Forsyth County, North Carolina." Manuscript. Wake Forest University Archeology Laboratories, Winston-Salem, North Carolina, 1985.

South, Stanley. "Discovery in Wachovia." Manuscript. Old Salem, Inc., Winston-Salem, North Carolina, 1972.

Twin City Centennial, 1935.

WPA Slave Narrative Project. North Carolina Narratives, Vol. 11, Part 1. Federal Writer's Project, United States Work Projects Administration (USWPA). Manuscript Division, Library of Congress. DIGITAL ID. mesn 111/169165. [Esther Pinnix is also credited for this interview, and

Betty was misidentified in Rawick's *The American Slave*, also available at
http:// lcweb2.loc.gov /ammem/wpaintro/ wpahome.html.]

BOOKS

Cameron, J.D. *A Sketch of the Tobacco Interests of North Carolina*. Oxford: W.A.
Davis & Co., 1880.

Clewell, John Henry. *History of Wachovia in North Carolina*. New York: 1902.

Crews, C. Daniel. *Bethania: A Fresh Look at Its Birth*. Winston-Salem, NC:
Moravian Archives, 1993.

————. *My Name Shall Be There: The Founding of Salem*. Winston-Salem, NC:
Moravian Archives, 1995.

————. *Neither Slave nor Free: Moravians, Slavery, and a Church That Endures*.
Winston-Salem, NC: Moravian Archives, 1998.

————. *A Storm in the Land*. Winston-Salem, NC: Moravian Archives, 1997.

————. *Villages of the Lord*. Winston-Salem, NC: Moravian Archives, 1995.

Crews, C. Daniel, and Richard W. Starbuck. *With Courage for the Future: The
Story of the Moravian Church, Southern Province*. Winston-Salem, NC: 2002.

Eller, Ernest McNeill. *Bethania in Wachovia: 1759–1959*. Winston-Salem, NC:
Bradford, 1959.

Foote, William Henry. *Sketches of North Carolina, Historical and Biographical,
Illustrative of the Principles of a Portion of Her Early Settlers*. New York: Robert
Carter, 1846.

Fries, Adelaide, Stuart Thurman Wright and J. Edwin Hendricks. *Forsyth:
The History of a County on the March*. Chapel Hill: University of North
Carolina, 1976.

————. *Records of the Moravians in North Carolina*. 13 vols. Raleigh: North
Carolina Historical Commission (and successors), 1922–2006.

Hoyt, William Henry. *The Mecklenburg Declaration of Independence*. New York:
Putnam & Sons, 1907.

Hutton, J.E., MA. *A History of the Moravian Church*. Vol. 3. N.p., 1909.

Johnson, Guion Griffis. *Ante-Bellum North Carolina: A Social History*. Chapel
Hill: University of North Carolina Press, 1937.

Kapp, Louise Bowles. *Bethania: The First Industrial Town of Wachovia*. Bethania
Historical Association, 1995.

Ramsey, Robert W. *Carolina Cradle*. Chapel Hill: University of North Carolina
Press, 1964.

Rawick, George P. *The American Slave: A Composite Autobiography*. Westport:
Greenwood Press, Inc., 1979.

Reichel, Levin T. *The Moravians in North Carolina, An Authentic History.* Philadelphia: 1857.

Rohrer, S. Scott. *Hopes Promise.* Tuscaloosa: University of Alabama Press, 2005.

Saunders, W. L. *The Colonial Records of North Carolina.* Vol. 8. Raleigh, NC: 1890.

Sensbach, Jon F. *A Separate Canaan.* Chapel Hill: University of North Carolina Press, 1998.

Shirley, Michael. *From Congregation Town to Industrial City: Culture and Social Change in a Southern Community.* New York: New York University Press, 1994.

Sides, Roxie. *Early American Families.* Winston-Salem, NC: 1963.

Siewers, Charles N. *Forsyth County: Economic and Social.* N.p.: University of North Carolina, 1924.

Taylor, Gwynne Stephens. *From Frontier to Factory: An Architectural History of Forsyth County.* Raleigh: North Carolina Department of Cultural Resources, Division of Archives and History, 1981.

Thorp, Daniel B. *The Moravian Community in Colonial North Carolina: Pluralism on the Southern Frontier.* Knoxville: University of Tennessee Press, 1989.

Wheeler, John H. *Reminiscences and Memories of North Carolina and Eminent North Carolinians.* Columbus, OH: Columbus Printing Works, 1884.

Wiley, C.H. *The North Carolina Reader.* Philadelphia: Lippincott, 1851.

Wilson, Evelyn H., ed. *Dr. George Follett Wilson Journal.* Greenville, NC: A Press, 1984.

PLEASE NOTE

The spelling of names have changed over time. Names in this book have been spelled according to the original document(s) in which they were recorded. If anyone needs a specific reference, please feel free to write to me at:

Bev Hamel
PO Box 313
Bethania, NC 27010